THE EDUCATION OF MR. MAYFIELD

THE EDUCATION OF
MR. MAYFIELD

An Unusual Story of
Social Change at Ole Miss

by David Magee

John F. Blair, Publisher
Winston-Salem, North Carolina

JOHN F. BLAIR
PUBLISHER
1406 Plaza Drive
Winston-Salem, North Carolina 27103
www.blairpub.com

Manufactured in the United States of America

COVER IMAGE
Dr. Purser's Drawing Class

Unless otherwise noted, all artwork is from
The Baby Who Crawled Backwards: An Autobiography by M. B. Mayfield,
courtesy of the Pontotoc Historical Society, Pontotoc, Mississippi

Library of Congress Cataloging-in-Publication Data

Magee, David, 1965–
The education of Mr. Mayfield : an unusual story of social change at Ole Miss / by David Magee.
p. cm.
Includes bibliographical references and index.
ISBN 978-0-89587-366-8 (alk. paper)
1. Mayfield, M. B., 1923–2005. 2. Painters—United States—Biography.
3. African American painters—Biography. 4. Purser, Stuart R., 1907–1986.
5. University of Mississippi—Faculty—Biography. I. Title.
II. Title: Education of Mister Mayfield.
ND237.M41135M33 2009
305.896'073076283092—dc22
[B]
2009018745

www.blairpub.com

DESIGN BY DEBRA LONG HAMPTON

For my father, Dr. Lyman Magee,
who shared my enthusiasm
for this story but passed away
before its publication

CONTENTS

AUTHOR'S NOTE

This is a true story compiled from research and the recollections of people spanning more than seventy years. I have paid careful attention to factual accuracy throughout. In some instances, I have slightly expanded details that help bring key events back to life, but only when research made the suggestions. I should also point out that this story covers an era when unflattering words were used to describe African-Americans. Readers should note that I have employed these period-centric terms when appropriate to the events and dialogue of the time.

PROLOGUE

I wrote this book because stories of rare inspirational humanity need to be celebrated as the treasures they are. That and I fell in love with the leading characters, who quietly, almost sixty years ago, helped pave some once non-navigable paths that deserving others were later able to walk firmly upon.

My earliest memories of racial unrest in the community where I lived from birth until nearly age forty date back to the late 1960s. Oxford, Mississippi, was a town of fewer than four thousand residents in those days. The adjoining University of Mississippi, where my father taught and my mother worked, had about the same number enrolled as students. Seemingly a quintessential safe haven, it had a rather pointed and nasty history that made a young boy grimace.

Frequently for both reminder and understanding, I pulled from beneath my father's bed a large board that

held a collection of warlike paraphernalia, including expired tear gas canisters collected from the deadly riots of 1962 that stunned the world and scarred Oxford and Ole Miss, as the university was affectionately known. President John F. Kennedy sent the National Guard to restore order when James Meredith attempted to make history by becoming the first black student to enroll at the all-white university. White supremacists throughout the state rose defiantly to keep him out of Mississippi's flagship university. Even if they had not attended Ole Miss, they wanted its legacy preserved at any cost.

The story was one I knew all too well, even though it unfolded just before my arrival into the world. The hardware my father kept mounted on that board led me to reflect upon Meredith's admission time and time again. I had grown to love the university from my earliest days because it provided my family's livelihood, as well as an endearing atmosphere only a hardened soul could resist. But from 1848 to 1962, it did not allow blacks admission.

Meredith applied to Ole Miss knowing the implications. Under pressure from Governor Ross Barnett, the university denied the application because of Meredith's race. The United States government, behind pressure from Attorney General Robert Kennedy, pushed Barnett and Ole Miss to back down, demanding Meredith be admitted without consequence.

But Barnett was a showman, a throwback to old-time

stump speakers. He was not willing to back down to Uncle Sam's arm twisting. During halftime of the Ole Miss–Kentucky football game, held in Jackson, the state capital, the university's band marched before forty thousand fans waving Rebel flags. Caught up in the moment, Barnett took the field and grabbed the microphone on the fifty yard line moments after the band had unfurled what was claimed to be the world's largest Confederate flag. Old Ross's gravelly voice roared and quivered as he pointed his finger upward, working the all-white crowd into a frenzy.

"I love Mississippi. . . .

"I love her people. . . .

"I love her customs."

In response, the federal government ushered Meredith to campus the next day, before Barnett and university officials expected him. Word leaked out, though, and a riot filled with brickbats, lead pipes, and Molotov cocktails ensued. Two people died and dozens were injured, some seriously, all in the name of keeping a black man from enrolling in a public university. Under the pressure of mounting negative national publicity, Barnett backed off his stance against Meredith's enrollment. Federal troops restored order, and Meredith was admitted without further incident.

Ole Miss ultimately moved beyond its troubled past, becoming through four decades of deliberate effort an example of progress and forward thinking. But the Meredith admission disaster has never been easy to forget.

Most who witnessed the events from the inside were stunned at the escalation of violence. Many who watched from the outside wondered what kind of place could let such a horror happen. Americans had seen Oxford and Ole Miss at their worst, images from the evening news stamped in their memories.

I was never able to reconcile the incident either, even though I spent most of my life around the school I so loved. Years later, as an Ole Miss student, I watched fans wave Rebel flags by the thousands until the tradition was abolished in the late 1980s. And I was rarely able to enter the Lyceum, the original main administration building on campus, without noticing places on the white columns chipped by gunshots from the Meredith-inspired riots of 1962. Neither was I able as an adult to understand how so many good people sat silently in the shadows of the Lyceum that fateful day.

As a result, I often returned to the past in my attempt to reconcile how my small, picturesque hometown and school could have been so very dark and cold. I asked questions. I collected books, some written or compiled by friends, amassing a personal library of those dark days. Years later, whenever one of my own children had a paper to write for a grade-school history class, I always urged them to the point of eye rolling to do as I had done—that is, to pore over the racial history of Ole Miss so they, too, would have an understanding of both the pain and the progress experienced in our midst.

I was therefore engrossed when I began to learn the story of Stuart Purser, M. B. Mayfield, and Ole Miss, which took place more than a decade before James Meredith's enrollment. Some uplifting stories from the darkest days of the twentieth century were never recorded by the history books or covered in the news. One has to look a bit harder to find those quieter acts of courage not captured by the media. This one in particular was buried deep in obscure memories, but it grabbed me from the first moment. I have not been able to let go since.

I should have known about Stuart Purser and M. B. Mayfield. I grew up at the university's feet before entering the grasp of its comforting hands. My first hero in red and blue was football quarterback Archie Manning. My second was an equally proficient player who later starred on defense, Gentle Ben Williams, the school's first black player. The only memorable papers I wrote in school were about racial change at Ole Miss.

Later, as a newspaper editor in Oxford, I wrote a story about how Ole Miss had enrolled its one thousandth minority student for the year, understanding how far the university had come from James Meredith's day. What I did not know, however, was that courage and friendship had overcome racial barriers at Ole Miss long before 1962.

Never mind that my father had known Stuart Purser in Louisiana before either came to Ole Miss, or that the art professor and his family had lived for a year in a house next door to my childhood home. Never mind that a painting

by M. B. Mayfield hangs in the breezeway of my family home. Like many gems of the pre-civil-rights era, the story of the teacher and pupil had remained obscured from me and most everyone else who studied the university. The few people closely involved kept a silence respectful of a different era.

In the later years of his life, Mayfield quietly acknowledged what had occurred at Ole Miss in the middle of the twentieth century, more than a decade before forced integration. But little was known about this remarkable story other than a few tantalizing tidbits. Thus, when first hearing about it some years ago, I was moved to pursue the story of Stuart Purser and M. B. Mayfield. My aim was simple—to find the missing pieces and put them together in a manner that would allow others to know the details of one man's unusual and inspiring education at Ole Miss, an education that, according to the rules of the day, should never have happened. What I found was a sometimes surprising and always meaningful story of friendship and opportunity, of two men beating a flawed system with their ingenuity.

This book is the result.

CHAPTER I

PINE KNOTS AND PREJUDICES

For many years, tall trees waved in the wind as far as one could see across the central Louisiana flatlands of LaSalle Parish. But the arrival of the sawmill in the 1920s changed everything.

The indigenous pines that anchored such rural areas were harvested to meet the nation's growing demand for cut timber and pulpwood. Trees were harvested as fast as mill owners and operators could get them cut and processed. Replanting rarely occurred, leaving fields of scrub and a changed landscape.

Amid land left unprotected and parching in the sun, communities sprouted like well-watered seedlings. Workers moved in to meet the growing demand for labor at the mills. Schools were built and churches established.

The Pursers from southern Arkansas were one of many families that found opportunities in LaSalle Parish,

moving to the town of Good Pine. Mr. Purser worked at the local sawmill and became a member of the school board. He also taught a youth Sunday-school class at church. Mrs. Purser worked in the home and spent considerable time making sure her family followed the word of God. Their two children were an older daughter and a younger son.

Stuart Purser was eight years old when his family moved to Good Pine. He adapted quickly to friends and school. He had the quintessential family life, including a hardworking father, a Bible-revering, children-devoted mother, and a confidant sister two years his elder. The family traveled together in the summertime for two or three weeks to see Stuart's mother's family in Oklahoma and Texas and his father's in East Tennessee.

Purser was a wiry lad who liked drawing as a hobby, using art supplies given by his mother's family for Christmas presents most years. But at an early age, he spent more time with a pellet gun and a .410 shotgun, gifts from his father, who did not want his boy to be a sissy. Purser tramped the fields and wetlands around his home with a pellet rifle searching for quail and mallard ducks until his mother suggested that killing for no reason was against God's will. So he stopped. On Friday evenings, Purser would find notes written by his father of chores to do over the weekend. He knew better than to ignore the lists, or a belt whipping awaited him.

He was eleven years old when he first collided with the harsher realities of life in Good Pine. Initially, he wanted

to dismiss what seemed obvious. But even a young boy had instincts. Sure, the white robe could have simply been unusual apparel. He knew better, though. The robe—adorned with a hood and bearing the insignia of a fiery cross, symbolizing a leader—was secreted in the farthest reaches of his father's closet. Purser was merely looking for his misplaced boots. He found his heart pulsating instead. Shaken, he shut the closet door and forgot about the boots. The robe had looked identical to those he saw periodically on the front page of the weekly parish paper, the *LaSalle Times*, and he could not get the sight out of his mind.

The year was 1918, and Good Pine was more a crossroads than a town, despite the growth fueled by the timber business. It was anchored by the Bradshaw Lumber Company mill. Two miles down Louisiana Highway 84 was the larger parish seat, Jena (pronounced Jeen-a).

Lumber production had been almost nonexistent in Louisiana until the early twentieth century. But as wood supplies in the East diminished, timber companies set up mills in pine-rich northern Louisiana. Since rural communities like Good Pine had little infrastructure, mill operators often had to provide housing, law enforcement, and even school funding to bring enough workers to town. The fast-paced production at sawmills required hundreds of hands. Workers were sought from throughout the region.

For Good Pine, one result of the newly created jobs

was a change in the community's racial and geographical mix. White Midwestern mill owners and bosses with names like Ludwig, Hansen, and Mann migrated south from Wisconsin and Minnesota. The community also had a large collection of local natives referred to as "Lakites." A mix of French, Indian, and Spanish heritages, they lived in low, swampy sections between Good Pine and the Mississippi River bottoms bordering nearby Catahoula and Concordia lakes. Cajuns moved into the area from southern Louisiana for work. So did Anglo-Saxons like the Purser family, from places like southern Arkansas, eastern Texas, and northern Louisiana. Negroes, as they were called by the more discerning nonblack residents, made up 40 percent of the population.

The mill owners and bosses were among the more powerful members of the community. They often lived alone, leaving their families back home. Supported domestically by black help during the week, they sought entertainment and refuge in larger cities like Alexandria and New Orleans on the weekends.

Locals identified the working-class Lakites by their dark, almost smoky, reddish complexions. Most whites considered the Lakites' lineage to be partly Negro. Whites were also disturbed by the Lakites' clannish behavior and their preference for hunting and fishing over working in the mills. But the Lakites were also known for their fearlessness and for being excellent workers when so inclined, so they were tolerated most of the time.

The Cajuns kept mostly to themselves, living carefree lives highlighted by Saturday-night community parties of drinking, dancing, and frivolity called fais do-dos. Nobody had much trouble with the Cajuns unless they tried to crash one of the parties without an invitation. Most people knew better, of course.

Negroes were assumed by local whites to consist of two factions. One included longtime residents who grew up working on farms in the region. They could be trusted. The other was a smaller group that had migrated to central Louisiana from the east in search of work, moving from fishing and riverboat jobs along the Mississippi to employment in the timber industry. Whites considered these blacks to be drinkers and gamblers in possession of a mean streak.

LaSalle Parish was under the order of a sheriff and deputies, but they were understaffed and had little influence among citizens. The supreme law in the community was dictated by a less recognizable but much more powerful group. More than half of all white men in LaSalle Parish were sworn under oath to protect the white citizenry using whatever means necessary as members of the Ku Klux Klan.

Members justified violent actions—including threats, beatings, and lynching against blacks believed to have acted disrespectfully toward whites—as "sending a message" or as "God's justice." No other explanation was necessary.

Founded in Tennessee in 1865 in the aftermath of the

Civil War as a means of keeping newly freed blacks from obtaining equal rights, the Klan had all but died out in the South by the turn of the twentieth century. But a regional rebirth was well under way by Stuart Purser's childhood as whites sought to maintain power and their view of rightful order in labor-sensitive areas with black populations. The all-male Klan membership paid dues to the brotherhood and wore white robes with hoods to cover their identities. More often than not, the rolls included church members and business owners, self-professed men of God and pillars of the community.

Drawing strength from a national association stretching from New Orleans to Memphis to Detroit that grew to four million members by 1920, the LaSalle Parish Ku Klux Klan controlled matters of law and morality, particularly those involving blacks and other non-whites. Most times, life in LaSalle Parish was quiet and the Klan went unnoticed. Men worked in the sawmills and other businesses, while women tended the households and children went to school. Community members in good standing were expected to be in church on Sunday.

Yet tension was always present. When the women and children settled quietly in their homes at night, white men of the community, including Mr. Purser, reached into their closets, pulled out their white robes, and rode off in pickup trucks to destinations unknown to everyone else. They did not speak of where they went or what they did. They did not have to. If a black man, or even a white

on occasion, was not providing for his family, or was drinking heavily, or was gambling and fighting, or was creating disturbances, and the sheriff failed to properly punish him, the Klan would administer lashings or issue stern warnings. Or even worse, as Stuart Purser discovered one Friday afternoon just before school dismissed for the week.

He was waiting to play in a pickup basketball game with friends when he noticed a group of boys in a huddle just off school property. Curiosity got the best of him. Moving closer to the group, he recognized Tom Girley as the young man on the stump. Girley, a Lakite boy a few years older than Purser, had a long rope in his hands and was speaking in an evangelistic cadence.

"Sure," he told the assembled crowd, "this is the rope. If you don't believe it, you can ask the sheriff at Little Creek. He is the one who gave it to my dad. My dad said they might need it again if some of these niggers don't take notice. But to cut this ten-foot piece wouldn't hurt it any. He says that every real man should have a piece of lynching rope over his mantel to remind him of his duty to protect his woman against niggers."

Little Creek was another crossroads community in LaSalle Parish. Located six miles from Good Pine, it had a post office and a store to serve its fifty-two residents. Purser was told by a friend in the gathered crowd that a nigger boy had raped a white girl at Little Creek, and that the Klan had taken the law into its hands, hanging the boy

with the rope now on display.

The boy on the stump was cutting the rope into eight-inch pieces and bartering the small keepsakes for valuables like marbles and arrowheads. He offered a rope piece to Purser in exchange for shotgun shells, but Purser declined without responding, backing away from the crowd. The backs of Purser's eye sockets felt as if they were being pressured in a vice. Nauseated by the sight of a rope that had hanged a boy to death, he eventually had to lie down to gather his thoughts.

By the time he reached home, Purser was shaking with sobs. He knew he could not discuss the incident with his father. He had seen the robe in the closet. But neither could he swallow his question any longer.

After a restless night crowded with images of what the black boy might have looked like dangling from the rope, he awoke on Saturday morning to an invitation from his father to join him on a drive to Jena. Purser declined, seeking time alone with his mother.

Sensing he was disturbed, Purser's mother invited him to sit in the porch swing with her. Comfortable at his mother's side, he finally asked the question he had held so closely.

"Mother," Purser asked, "is Dad a Ku Klux?"

His mother did not answer directly, but neither did she avoid the truth. She believed the Klan was necessary for law enforcement until the sawmill owners provided more officers for the sheriff. The local mill had created the

sheriff's department and paid the sheriff and his deputies. But because law enforcement officers worked for the mill, not the people, they were largely ineffective.

Good Pine, Purser's mother said, was a different kind of town with different kinds of people, a place void of capable and willing law enforcement. She suggested that their fellow church members lobby the mill owners for more officers and "really pray" over the situation.

Convinced his father was in fact a member of the Klan, Purser asked an even more pressing question.

"Mother, did Dad help hang the Negro at Little Creek?"

His mother looked away before replying.

"No, son," she said. "Your dad did not, nor did the Klan take part in the lynching at Little Creek. It was done by the father of the girl who claimed that she was raped, with the help of kinfolks and others in the community."

She was sorry for the Negro boy who was hanged but just as sorry for the boys who would want such a souvenir as a piece of the rope that killed him. She would ask the ladies of the church to pray for the boys, who had obviously "not had the right teaching."

Most of the boys were members of his father's Sunday-school class, but Purser knew the lynching would never be mentioned there. He did notice, however, that the pastor spoke from the pulpit of the wrongness of teaching children to celebrate such cruelty, undoubtedly because Mrs. Purser had talked to him about it. His mother

further warned Purser and his sister about subscribing to the "wrong kind of thinking in the world."

His father's Klan membership did not dictate the family's friends. Among the Pursers' favorite people in the community were the Jacksons, a black family living two miles outside Good Pine. Seventeen-year-old Emalina Jackson, who was said to have the natural beauty of an Egyptian princess, helped Mrs. Purser with cooking and cleaning. But she was more than just domestic help. She was a friend and confidant—as much as a young black girl could be to an older, married white woman.

Emalina's brother, named Henry at birth but nicknamed Applehead as a child, was Stuart Purser's age. The boys hunted and fished together year-round. Purser's father even hunted on a regular basis with Applehead's father, Old Newt, and brothers Young Newt and Chris. Mr. Purser routinely took members of his Sunday-school class possum or raccoon hunting on Saturday nights with the Jacksons, letting Applehead and Stuart come along. The group would meet at seven in the evening and hunt past midnight. The excursions were unpopular with many church members outside Mr. Purser's Sunday-school class, probably because of the racial mix of the participants and the late nights. The hunts made for exemplary Sunday-school attendance, however. Mr. Purser believed they kept boys from Saturday-night waywardness.

Emalina was a professed Christian who held Sunday-

school classes for area children in her home, using lessons purchased and donated by Mrs. Purser. She had aspirations of attending all-black Grambling University and becoming a schoolteacher. To earn more money for her education, she took a job cooking and housecleaning for a single white mill boss many years her elder. The work paid well for the time and place, but she found the mill boss wanted more than her domestic services in return. One day's friendly pat on the arm became another day's grope of the buttocks, which became another day's direct invitation for sex.

"Why don't you lie down with me?" the mill boss inquired.

Emalina was stunned silent, turning down wordlessly the offer of a three-dollar-per-week raise in return for sex. She needed money, but not at that price.

The mill boss said, "Fine, then." Emalina should suit herself. "Leave town by Monday," he ordered.

Later that day, the sheriff paid Emalina a visit and told her the very same thing.

"Leave town by Monday," he said.

Though the sheriff worked indirectly for the mill boss, he was also the designated law of the community. If he said to leave town, she had no choice but to obey.

The next day, Emalina choked back tears while confiding in Mrs. Purser what had happened. Mrs. Purser told her husband even though Emalina had asked her not

to. Mr. Purser was just as distraught by the news as his wife. He worked for the mill boss but liked the Jackson family.

When Mr. Purser visited the mill boss to discuss the situation, he lost his temper midway through a terse conversation. In a raised voice, he accused the man of preying on the young lady.

"You old bastard," he said. "You are not fit to sleep with the dirtiest Negro girl alive."

Probably because of his stature with the Klan, an organization feared and loathed by the mill bosses, Mr. Purser did not lose his job. But Emalina did leave town, living for a spell with relatives elsewhere in the state. Weeks later, though, Mr. Purser announced to his family that Emalina was coming back home. He even drove to the train station to pick her up and delivered her and her luggage to the Jackson home.

Over the years, Stuart Purser's friendship with Applehead flourished. They did not attend the same school, of course, since blacks and whites learned at separate facilities. But after classes and home chores, Purser and Applehead were often together, mixing like sorghum and biscuits.

Tall and skinny, with a small head that inspired his nickname, Applehead was the youngest of the Jackson boys. He could run faster than all his peers, was the best at any sport played by boys black or white, had a knack for fishing and hunting, and was smart. Applehead was also

thrifty and dependable and could not tell a lie.

Purser often walked the several miles to the Jackson house. He played there for hours with Applehead's three pet raccoons and in a nearby creek that ran behind the home. Purser's father admired Applehead, considering him a worthy friend for his son. He did not object to the considerable time they spent together, including meals at the Jackson home, where the featured dish was possum and sweet potatoes.

Applehead often professed love for his pet raccoons, handling them in their large pen the way other people played with their cats and dogs. He once confided to Purser that he did not understand why white people called blacks "coons" to suggest their worthlessness.

"Coons are not worthless," said Applehead. "They can say whatever they want about me, but suggesting a coon is no good just makes me furious."

When Purser was fourteen, he and Applehead were still part of Mr. Purser's Saturday-night possum hunts. Tom Girley, the Lakite boy who had sold pieces of the lynching rope at school, joined the group, too. Girley, known as a troublemaker, had twice run away from home. But he was a hero among many of the white boys in LaSalle Parish because of his strong-willed, rebellious personality. He and Purser were little more than indifferent acquaintances, however, the result of the rope incident and a beating Girley once gave Purser over a prank pulled at Girley's expense during a church service.

On one hunt in late November, Mr. Purser could not go along. In his absence, Tom Girley and several other Lakite boys were left to their own imaginations without adult supervision except for Old Newt, Applehead's father. The group was just about to call it a night when Old Newt's hunting dogs ran a raccoon up a tree. The Lakites brimmed with anticipation. Girley and his friends thought good entertainment would come from wresting the raccoon from the tree to let it fight on the ground with the dogs. Raccoons always lost such encounters eventually, getting ripped to shreds by the dogs, but some could fight for hours, a possibility that made an otherwise routine central Louisiana night positively captivating for the Lakites.

Old Newt disapproved of the fight, but the Lakite boys would not listen to the black elder. Girley picked up a sharp stick, gouged it into the treed coon's fur, and twisted it in an attempt to cause enough pain that leaving the tree to join the boys and dogs on the ground would seem appealing to the animal. The coon squirmed and squealed.

Girley's attack and the animal's discomfort struck Applehead hard. He broke out running toward Girley. He kicked Girley in the shins and punched him before the boy could respond. Applehead knew in the deeper reaches of his mind that a black could not strike a white, even if provoked, but he simply could not stop.

Incensed by the attack, Girley lunged back at Applehead, yelling that he would "kill the coon," but the other boys held him back. With Old Newt there, they could not give the Negro the beating they felt he deserved. Girley and Applehead parted ways that night without making peace.

Several years passed. Nothing more came of the incident, though it simmered with Girley. Applehead avoided the Lakite boy but held him in silent contempt.

Stuart Purser went away to college, attending a small, all-white Southern Baptist school in nearby Pineville, Louisiana. He majored in art, his passion, focusing on painting, landscapes in particular. He and Applehead continued to see each other whenever possible. He began referring to his friend as "Ap." When Purser was home for Christmas his freshman year, he and Ap duck-hunted together. And in June 1925, after Purser's freshman year, he and Ap entered the annual local fishing contest they had won three out of the past four years. They triumphed again, thanks to a full stringer of bream.

In the weeks after the fishing contest, Purser traveled with his family to East Tennessee to visit relatives in the Dayton area, where the Scopes Monkey Trial happened to be under way. High-school teacher John Scopes had been charged by the state of Tennessee for unlawfully teaching evolution in the classroom. The American Civil Liberties Union–inspired case made national news, pitting man's

evolution from apes against the Bible's divine creation. To reinforce the theory of evolution, a New York lawyer who was a member of the defense team brought a trained chimpanzee to Dayton to show how closely related it was to man.

When Purser and his family heard the chimpanzee was going to be at a Main Street diner in this small town, they went together for a bite of lunch. Dressed in a gray tweed suit with a red tie, the chimpanzee pulled out chairs and seated those at its table, tucked a napkin into its shirt before dining, and puffed on a cigar after the meal, blowing smoke rings. When the New York lawyer saw Purser's uncle Jack across the room, he approached and made mention of Jack's receding forehead and protruding chin.

"This is the perfect example which proves man evolved from the ape," the lawyer said loudly, so everyone in the diner could hear.

Angered by the man's words, Uncle Jack stood up. His fist closed.

Whack.

The lawyer fell to the floor.

The local police arrested Uncle Jack for assault, but the charges were later dropped.

Stuart Purser was mostly amused by the event. His brief brush with the Scopes trial was further evidence of his conflicted South.

One week after registering for his sophomore year at Louisiana College, Purser received an early-morning telephone call from his father urging him to come home at once.

"Ap is in trouble," his father said.

Purser boarded a bus in Pineville on a Thursday morning and arrived in Jena that evening. His father picked him up at the bus station and filled him in on what had transpired.

The previous Saturday night, the local Negro baseball team had played against the Natchez (Mississippi) Blues. Customarily, local whites showed up to watch the black teams because the play was so competitive. Among the observers that night was Tom Girley, who watched with friends from the third base line. He was close enough that the players could easily hear his remarks.

Ap played for the local black team. When he came to the plate, Girley yelled to the pitcher, "Throw him a sweet potato with a little possum grease on it! Maybe he can hit that!"

The pitcher warmed to the conflict. He threw his first ball high, hard, and inside, brushing Ap's chin and knocking him to the ground.

The crowd murmured.

Ap stood up, brushing off dust.

"That's right!" yelled Girley. "Kill the damn coon!"

Ap heard the remark clearly.

Kill the damn coon?

Ap turned and hurled his bat in the direction of Tom Girley's voice.

Girley saw it coming and ducked, but it struck an eight-year-old white boy in the temple, sending him to the emergency room at the Jena hospital.

The sheriff arrested Ap on a charge of assault. But since Good Pine did not have a jail, he was held temporarily in a back room at the local doctor's office.

That night, a group of angry Lakites came to get Ap for lynching. The sheriff suggested they wait to see whether the injured boy lived or died before dealing with Ap. If the boy died, lynching would be in order. If he survived, a good scar-inducing lashing might suffice.

Ap overheard the conversation.

After the crowd dispersed and the sheriff left, Ap removed putty from a window sill, slid out the panes, and escaped, running into the nearby pinewoods.

The bloodhounds sent out the next morning could not find Ap. Days passed with no sign of the escapee.

Mr. Purser suspected Ap was still in the area and thought Stuart could find him. If someone did not reach him quickly, the Klan would sooner or later get him and almost certainly hang him, producing another souvenir rope for Girley.

Fellow KKK members had been pressing Mr. Purser for a meeting to decide what to do about Ap. Most had no idea Mr. Purser knew the escapee so well. Mr. Purser had

refused calling a meeting, causing members to question his leadership, but he could not stand the thought of Ap being lynched.

If Stuart could find Ap, perhaps they could help him.

Sure enough, within an hour of beginning the search for his friend, Stuart Purser found Ap near the fishing hole they had used to win the recent contest.

Ap's first question was about the condition of the boy struck by the bat.

"He's shown improvement," Purser said. "He's going to be okay."

Ap was relieved.

"We have to get you out of here," Purser said.

Ap did not want to run away.

"If only I could have a fair trial," he said.

But a black man who had injured a white boy in Good Pine could not get an impartial jury. And the Klan would likely not allow him to reach trial anyway. So Mr. Purser coordinated with the sheriff to formulate a relocation plan for Ap. They would pick him up at midnight and drive him to another parish, leaving him in the hands of the local sheriff. He would face trial there.

They left as planned for the transfer. On the other side of Jena, they saw in the distance thirty or more cars gathered in an empty lot illuminated by flames. Light from the fire revealed men wearing white robes.

The Klan must have received a tip, Mr. Purser assumed.

He turned the car around, afraid the group might try to intercept it and take Ap. Mr. Purser told the sheriff they should try again the next night. The sheriff agreed.

Mr. Purser took the sheriff home and returned Ap to his hiding place.

Back at the house, Mr. Purser confided in Stuart that he feared Ap would never be treated fairly if left with law enforcement in any parish in Louisiana. Perhaps, he suggested, Ap should be encouraged to run away from LaSalle Parish that very night. If Ap left soon, Mr. Purser said, he could be in northern Louisiana or Arkansas before the sheriff or anyone else started looking for him.

Stuart Purser did not want to see Ap run away from punishment. But like his father, he knew if Ap did not flee, the Klan would eventually find him and probably kill him.

Agreeing on the change in plans, Stuart and Mr. Purser drove in the early-morning hours to meet Ap. They gave him a knapsack containing food, a jacket, and seventeen dollars and instructed him to leave immediately, heading north.

They then watched him disappear into the dark of night.

The sheriff never told anyone that Mr. Purser had helped Ap get away.

Ap made a new life for himself after the escape, first working in another Louisiana sawmill town and later in St. Louis, Missouri. The boy he had injured survived, but

only after a lengthy recovery of more than a year. He had to have a metal plate placed in his skull.

Mr. Purser later learned the Klan had not been waiting for them that night as he assumed. Rather, it was meeting instead to elect a new high official to replace him.

He permanently distanced himself from the Ku Klux Klan after the incident.

Stuart returned to college, his life marked by his experiences growing up in LaSalle Parish.

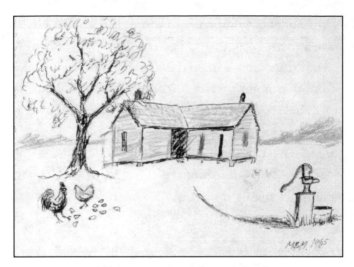

Old Stomping Ground pencil sketch

SHADES OF ECRU

The promise was simply too good to pass up. The gentle hills rolling across northeastern Mississippi acted as a segue between the abrupt, mountainous terrain to the east and the fertile river bottom land to the west. In the 1800s, those hills beckoned white Southerners seeking affordable and picturesque land to farm.

Settlers moved south from Tennessee, Kentucky, and elsewhere to claim for pennies on the acre lands once inhabited mostly by the placid, efficient Chickasaw tribe. The fields were a combination of red clay and rich soil.

And wildlife was prolific in and around Pontotoc County. Deer were so plentiful that one settler hunted the woods with only an ax.

The farmable land did not produce yields of cotton and wheat rivaling the nearby Delta region, but nobody seemed to mind. The affordability and beauty of the land provided opportunities for thousands of transplants in the middle of the nineteenth century.

From 1840 to 1850, the population of Pontotoc County increased more than threefold, from 4,491 to more than 17,000. Most transplants were farmers—and farmers, of course, needed labor to plant fields and harvest crops. The slave trade provided field hands. By 1860, Pontotoc County had 7,368 taxable slaves working on farms. The black population dropped by 40 percent after the War Between the States, due to casualties from fighting and the migration of freed slaves. But by the 1920s, black residents made up roughly 40 percent of the county's population. Because most either labored for white farmers or worked land of their own as sharecroppers, they escaped many of the problems that plagued places like Louisiana's LaSalle Parish.

Still, Pontotoc County had a chapter of the Ku Klux Klan. Some lynchings occurred in the area, but they numbered only a few among the total of blacks hanged by lawless mobs elsewhere in Mississippi and neighboring Alabama and Louisiana. Segregation ruled all facets of life. Most Pontotoc County blacks knew their place, and most

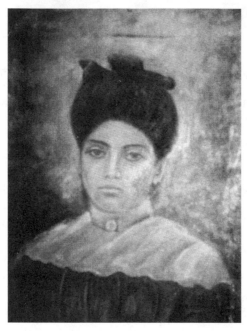

Mayfield's portrait of his mother

whites were fine as long as it stayed that way.

The Mayfield family lived in Ecru. A town of fewer than a thousand residents, it was small enough that most everybody knew one another's name and whereabouts but big enough to have a train depot, a short Main Street, a movie theater, two doctor's offices, and a hardware store. The Mayfields were descendants of slaves who chose to remain in the area following freedom. The mother, Ella, gave birth to twelve children, among them fraternal twins M. B. and L. D. on April 26, 1923. The boys were born in the midst of a thunderstorm, passing from their

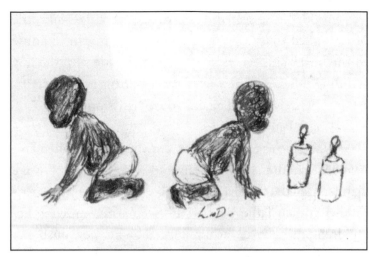

Pencil sketch of the infant twins M. B. and L. D. Mayfield

mother while she took refuge in a cramped storm shelter as lightning cracked in the night. They were not given names, but initials as names. Ella could not say why.

Months later, the boys learned to crawl at about the same time, as twins often do.

L. D. moved forward.

M. B. went backward.

Their father died of complications from tuberculosis just before Christmas 1925, when M. B. and L. D. were not yet three years old. The funeral procession became M. B.'s earliest memory. His father's body rested in a plank coffin carried on Christmas Day by a weathered horse-drawn wagon. Family gathered on the dirt driveway outside the Mayfields' unpainted farmhouse to say goodbye. A cold wind whispered across the pale brown countryside.

Prodded by a seated driver dressed in a dark suit, the horse pulled the wagon and coffin away from the house to the burial site. M. B.'s aunt Prudie made sure the boy standing at her feet knew who was departing as the wagon's tall iron wheels rotated against the Mississippi soil.

"That's Papa," she said.

Tuberculosis plagued poor, crowded households. Five Mayfield children—three sons and two daughters—were claimed by the untreatable disease in the several years following their father's death. Ella remarried, moving her children onto a small farm managed by her new husband. He had five children. She had seven. The *L*-shaped clapboard house he owned had a breezeway that made summer nights more tolerable and an outdoor chimney that warmed tingling hands in the winter.

A railroad ran adjacent to the house. A train lumbered on the tracks two times daily, heading one direction, then back. Chickens roamed the yard, as did a white dog named Whitey. The dog showed up as a stray and Mayfield tried to run her off, but she flashed her teeth in resistance and became a family pet.

A well pump dispensed water. Clangs came daily from a blacksmith's hammer striking hot iron in a shop behind the house. An unpainted swing hung from rusting chains on the small back porch. A tractor-tire swing weighted with three inches of swamp-smelling water hung from a tattered rope tied to a tree. Untamed field grass and shrubs grew so close as to often brush the house.

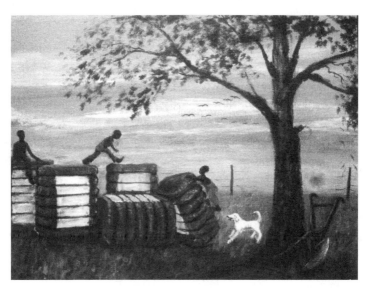

Bales of Cotton #2, showing Whitey the dog

The home had a steep roof and felt like an oversized nest with thatch walls. The rooms managed to fit the entire family but didn't afford much privacy. The boys shared one room and the girls another. The family cooked at a wood-burning stove and warmed the house from a wood-burning heater. They used the heater to prepare no-cost snacks, parching horse corn, which smelled and tasted like corn chips, and frying blackbirds killed on the farm with a single-load shotgun.

The walls were papered with yellowing back issues of the *Memphis Commercial Appeal.* The comic strips, extended sports section, society page, and other parts of the Sunday edition were sufficient to cover most of an

entire wall. The house read like a current-events mosaic of the South, the news and entertainment from one week giving way to another, wall by wall and room by room. The death notices, news photos, and recipes covering the walls hummed and rattled when the wind blew hard enough to seep through the cracks.

For the family, the newsprint provided a thin layer of insulation. For M. B. Mayfield, it also provided education and entertainment. The only book in the house was the Holy Bible, and it was rarely opened.

He read outdated news stories lining the walls and mimicked his favorite comic strips in drawings and doodles. Mayfield's favorite strips were "Bringing Up Father," "Andy Gump," and "Little Orphan Annie." He spent hours redrawing his favorite characters in pencil and bringing them to life with crayons that were Christmas gifts or leftovers from school or with an inexpensive set of watercolors. He selected and ordered the watercolors from a Sears Roebuck catalog, spending his entire amassed fortune of pennies. He watched for the mail delivery every afternoon until the order finally came.

Mayfield attended a one-room school for black students in Ecru. The Judon School was named for his grandfather on his mother's side, Adam Judon. The Judon family was one of Pontotoc County's most educated black families. Mayfield's first instructor was Miss Minnie, who played music on a phonograph, lining the students up to march to the tunes. Her favorite selection was "Darktown

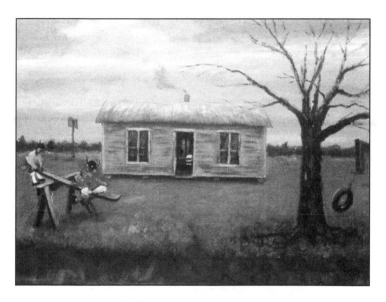

Judon School—New Building

Strutters' Ball," an early traditional jazz song written by Shelton Brooks that became a standard as one of the first commercial jazz recordings. While the band Six Brown Brothers played and sang, Miss Minnie directed her students like a band leader. Mayfield and his classmates participated in response, moving their legs up and down as if they were members of a military marching band.

Dressed in patched, well-worn clothes and often barefoot, the children learned the essentials of reading, writing, and arithmetic until eighth-grade graduation. They were also taught with a firm hand the importance of obeying authority. After all, they had to learn how to survive in a world where the choices were drinking from the "Colored" water fountain or drinking from no fountain at all. When Mayfield misbehaved for Professor Woods, a later teacher, one morning in the 1930s, he received a firm whipping.

But Mayfield spent many days of his youth making fond memories. He attended with family the Ecru Second Baptist Church, housed in a one-room clapboard building under a large oak tree. Sunday mornings, the church swayed along with the overhanging limbs when the all-black congregation gathered. Referring to themselves as brothers and sisters, members sang hymns and spirituals with feet pushing to the floor, hands reaching to the sky, and voices crying out together in textured harmony.

Sisters dressed in bright colors clustered together

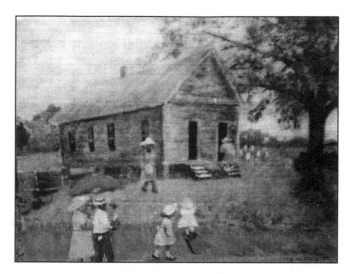

Ecru Second Baptist Church

in the front pews at the preacher's right hand, shouting, children at their sides.

"Oh, Lord, hallelujah!"

"Dear Jesus, thank you. Thank you, Jesus!"

Scattered throughout the sanctuary, brothers dressed in dark pants stood tall while murmuring affirmation of the sisters' calls.

"Mm-hmm. That's right."

Sometimes, the amen corner where the sisters gathered was a flurry of unbridled energy. Cries rang out. Arms flailed.

Mayfield was once struck in the jaw by a sister's wayward motion, which left him with a lasting sense of

discomfort within the small church. He was most fond of worship in the summertime, when different black congregations in the area took turns holding revivals, each lasting a full week. Members moved from one church to another for a month in succession, joining for days and nights of hymn signing, preaching, and fellowship.

Children playing outside watched the buildings vibrate as parents and family members gathered inside sang spirituals including "Swing Low, Sweet Chariot" and "Is There Anybody Here Who Loves My Jesus?" Individuals took turns with the vocal lead. Nobody sang the songs better than Aunt Hanna Golden and Mrs. Callie Bradley.

> Is there anybody here who loves my Jesus?
> Anybody here who loves my Lord?
> I want to know if you love my Jesus.
> I want to know if you love my Lord.

Young Mayfield knew revival season meant long wagon rides home from different churches on the starlit roads of Pontotoc County. The farther the church, the better. Honeysuckle growing along fence rows produced the sweetest smells on the warm nights. Unseen locusts whirred summer songs. Sweat beading on his brow cooled as the plodding horse moved through the still night. Tiny dirt roads heading nowhere became pathways to anywhere.

Mayfield was busy outside of summer church

meetings. The town had a movie theater on Main Street with separate seating for Negroes, and a dime store for candy treats when a few pennies landed in his pocket. He had brothers and sisters and friends from school. They found hours of entertainment playing with tops, balls, miniature cars, rag dolls, slingshots, popguns, and playhouses.

M. B., L. D., and little brother Junior made a threesome. Neighbors called the boys little devils for their harmless mischief, like skinny-dipping in a local swimming hole and tossing their straw hats toward passing trains. Junior's new hat once landed in an open boxcar, traveled quickly up the track, and was gone for good. Back at home, he got a whipping from his mother and endless teasing from his brothers and went hatless the rest of the year.

Skinny Dipping pencil sketch

The Angry Professor pencil sketch

Another time, the boys used their slingshots to ping stones at a family hen roaming the yard. They thought the hen was ugly, so they pelted her until she died from a crushed skull. Though they buried the carcass under brush in the nearby woods, their mother suspected foul play. She questioned the boys, who broke and confessed. Their mother lashed them each with a firm willow stick.

Sometimes, while the other children played outside, Mayfield retreated to his room to draw pictures and allow his mind to take him wherever it might. Among his first sketches was a pencil drawing of a young, overalls-wearing

boy fleeing a teacher swatting after him, switch in hand. Titled *The Angry Professor*, the drawing showed the student running, arms outstretched, full lips protruding.

Mayfield needed time alone, away from crowded sanctuaries and his small schoolroom. Sketching focused his mind. He was close to his mother, brothers, sisters, aunts, and cousins, who understood his kind heart and his desire to please. Mayfield rarely spoke ill of others and never minded making do with what he had. His words were few, but he was quick with simple, kind gestures.

One day, while rain fell and lightning cracked, he and other family members were sheltered well in their Ecru farmhouse, unconcerned with the dangers outside. Not far away, however, his cousin Nell just happened to be walking home from town when the storm erupted.

Crack.

And she was gone.

Once the news spread, residents arrived by the wagonload to see her motionless body in the road. Family and friends moaned the summer day Cousin Nell was buried. Mayfield was struck by the deceptive appearances of life.

Good memories were more plentiful. Ecru resident Murray Spain had an airplane that he landed in a pasture on weekends, giving rides above the Pontotoc County treetops to local whites. Mayfield sat for hours in an adjacent field watching the plane take off and land, wondering what it must be like to fly.

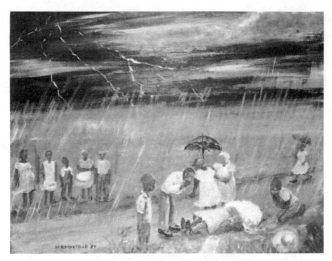

Tragic Monday, 1930s

Downtown Ecru's OK Theater had a balcony for blacks. Admission was ten cents to see a Western and more for a love story. Most Friday nights and some Saturday afternoons, Mayfield and friends and family went to the movies, sitting in the crowded balcony and eating gumdrops and raisins.

Contradictions were always close at hand.

Among Mayfield's favorite times was the end of the school year, when all the county's black schools gathered at Pontotoc Colored High School for Field Day activities. As the county seat, the town of Pontotoc was much larger than Ecru. Although it was mere miles away, a visit there was always a treat for children who lived in the rural areas of the county.

Field Day included sack races and leaping contests,

but Mayfield was not drawn to athletics. He liked instead to slip away to a nearby café where teenage boys and girls gathered around a jukebox booming out the day's latest tunes, like Glenn Miller's "In the Mood." On one such occasion, drawn by the Big Band sound and mesmerized by the dancing students, Mayfield moved onto the floor with a young lady about his age, fifteen. She had a heavyset physique and dark skin. Her curly hair was matted down and topped by a small brown felt hat resting on the back of her head. She wore a skirt that reached her ankles and a brown checked jacket that dropped below her buttocks to the tops of her knees. When Mayfield moved in for a dance, his first, he smelled the lard that pressed her hair closely to her head.

She had never danced before either, but the heat of the moment led them both to overcome their anxiety. They clasped hands, moving side to side as they had seen the other teenagers do. But everywhere Mayfield stepped, he found her foot. And everywhere the girl stepped, his feet were waiting.

Their concentration momentarily blocked out the rising volume of the crowd. But their awareness grew with each awkward step, until they realized most everyone in the café was watching and laughing.

Mayfield's face warmed. His stomach reminded him of the day he had bitten into an overly soft apple he found beneath a tree humming with bees.

The girl backed away, and so did he.

The laughter was not unfamiliar. Mayfield's twin brother, L. D., liked talking to girls. He, on the other hand, spoke in a way that sometimes led other boys to tease him. They made fun of his soft, sensitive voice. They ridiculed his rounded bosoms, his uncomfortable posture, the way he sometimes looked away from eye contact when talking, his tendency to wander off alone. Black boys were not supposed to be soft and sensitive, but rather tough enough to survive. They were supposed to have a strong, calloused grip and the temperament of a field horse.

Mayfield wanted to ignore the snickering, but it weighed heavily on him. He had long sensed he was different from others. Some people moved forward, others backward. Forward, backward, backward, forward—each was movement. Still, the painful barbs were like an endless stream of water running into a small cup. He sometimes felt he could not hold another drop.

Mayfield completed the seventh grade and began the eighth but did not finish, leaving school to work on his stepfather's farm. His widowed mother, with her high cheekbones and tapered chin, had been an attractive catch when she remarried, but she also had young boys and girls with years of productive physical work ahead—just what a man with a farm and little money for labor needed. Mayfield's soft hands were more comfortable holding a pencil and following the directions of his mind than grasping a plow and following his feet. Yet he did not dare suggest farm work was not his trade.

America was mired in the Great Depression of the 1930s. While life for families like Mayfield's was not noticeably altered, since money had always been scarce, children of all ages and both genders were expected to contribute to the household. His older stepbrothers—Papa Charlie's children—were hired out to area farms, leaving the younger children—including Mayfield, his twin, his younger brother Junior, and his three sisters—to help on the farm.

The family planted and tended a garden, growing watermelons, corn, okra, and other food for the table. They also grew cotton on Papa Charlie's hundred-acre rented plot.

The field needed plowing. The crops needed planting and picking. So Mayfield and his family members worked in the field while Papa Charlie was in the blacksmith shed forging plows and mending wagon wheels for paying neighbors, white and black.

But the Mississippi sun has a way of melting those who toil in it without a protective shell of indifference. Mayfield's twin brother could not do much of the work because of illnesses and failing eyesight. And the women of the house could plant and pick but were not allowed to plow with a mule under any circumstances. That left Mayfield to work Pontotoc County's clay soil behind a mule-drawn plow.

On his stepfather's rented farm was a big gabled home that had once been beautiful before it was abandoned.

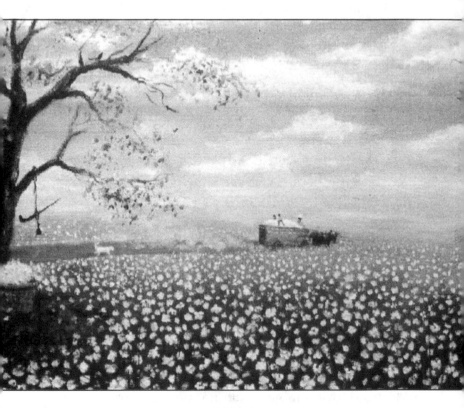

Headed for the Gin

The Old Beechum Place, as it was known, had been the home of a woman who loved flowers and fruit trees. But Mayfield's views of the house and the seasonal smells of flowering fruit trees, honeysuckle vines, and wild roses brought him little pleasure. He longed to escape the hot sun and the loneliness. Sometimes, he wanted his twin brother to come along and just sit in the shade and watch so someone, anyone, would be there. Instead, he plowed the fields alone.

As his twin brother's health improved at the same time Papa Charlie's declined, Mayfield understood that he would long be relegated to the role of plowman. Papa Charlie referred to L. D. with a nickname and showed fatherly affection toward Junior. But when he addressed Mayfield, it was only for the purpose of doling out chores.

"Plow the mule."

"Pick the cotton."

Mayfield's resentment toward Papa Charlie grew. The work was too hard. He sensed that his stepfather was following the same path as those who teased him. Papa Charlie seemed to consider him less than what was expected of a young black man of the South.

After Papa Charlie died in the spring of 1941, Mayfield's twin brother took charge of the farm. He, on the other hand, kept plowing behind the mule and tending to the heaviest chores. He was the family's workhorse. Mayfield managed to get the season's crop in the ground

that year, but the work took a toll.

He woke one morning not feeling well but unsure what was wrong. He was coughing, and his hands trembled. But he went to the field without telling anyone of his ailments. For several weeks, he tried toughing it out, working as expected, pushing ahead as an eighteen-year-old young man was supposed to do. Yet he remained weak and lightheaded. His legs wobbled like those of a newborn calf.

One day in the field, he could not take another step. Mayfield pulled back on the mule, let go of the plow, and walked home.

"I can't do this," he said.

For several days, he avoided the field and rested. Finally, he went to see the family doctor, E. B. Burns, at the suggestion of his mother. Examination revealed a small spot on his lung, indicating tuberculosis. The doctor said Mayfield was suffering from fatigue as a result of his illness. He prescribed ten days of bed rest in total isolation, along with heavy consumption of whole milk and vegetables, including peas, which Mayfield disliked.

On Mayfield's third day of following the doctor's orders, his disquieted mind shut down, his already fragile psyche shattering into sharp-edged pieces. The yellowing papered walls in the room told no stories. His beloved comic strips yielded no characters. Mayfield was despondent. He feared he might never again ride along the road to anywhere.

CHAPTER 3

INTRUDER IN THE DUST

All M. B. Mayfield could do for the longest time following his breakdown was open his eyes, close his eyes, and breathe. Time dissolved the way an unpicked melon seeps on an aging vine in the late-summer sun.

Over the next several years, he relied upon his mother for survival. She made his lunch. She cleaned his clothes. She did not ask when he might be able to work the farm again. Nor did she suggest he leave home to try and find work elsewhere. She merely provided her son constancy and care.

At the age of eighteen, Mayfield's twin brother met a girl and got married. After he was inducted into the army for service in World War II, he moved overseas for several years. Other brothers and sisters came and went as if the home were a train depot. Childhood friends left Ecru for factory jobs in the Midwest. Those remaining

home worked on cotton farms and started families of their own.

Loneliness reigned in Mayfield's world. Inspiration lay dormant.

The Holy Bible that had escaped Mayfield's examination for so long finally beckoned. On a particularly difficult day, he picked it up and opened it randomly. From the Book of Isaiah, the passage read, "Even the youths shall faint and be weary; and the young man shall utterly fall; but they that wait upon the Lord shall renew their strength; they shall mount up with wings as eagles; they shall run and not be weary, and they shall walk, and not faint."

His trembling hands stilled. His legs ceased wobbling.

They shall mount up with wings as eagles.

They shall walk, and not faint.

Words of God meant for him.

Mayfield drew strength from the passage, returning to it time and time again when he felt discouraged, depressed, or afraid. He emerged from his melancholia and found comfort in his drawing once more. He moved slowly, picking up a pencil here, outlining a sketch there, channeling his loneliness into a slow but steady heartbeat of creativity.

His finished works were mostly reflective re-creations of memories from childhood and the simple but memorable life of Ecru and Pontotoc County. One

Mayfield as a budding artist in 1949

pencil sketch showed three youthful, dark-skinned figures playing unclothed in a small swimming hole surrounded by cattails while a snake slithered nearby. Another was of the one-room Judon School as Mayfield remembered it from 1930, centered in a sparse landscape. No children or teachers appeared in the sketch—just the schoolhouse, its chimney, a small adjacent outhouse, some sparse shrubbery, a sign, and a basketball goal with a ball lying nearby on the ground. Like most of his work, it was detailed in outline but scant in depth.

He could not afford oil paints but sometimes splashed on colors he made from vegetables and flowers gathered from the farm. Boiled beets made magenta, onions yielded amber, and spinach made a light green. He smashed berries for deep red and flower petals for other hues. Red zinnias

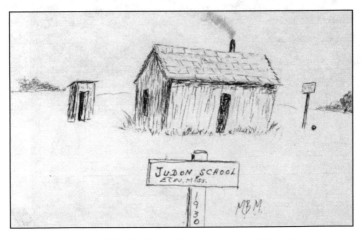

Judon School, Ecru, Mississippi, pencil sketch

worked well. So did morning glory blossoms.

Mayfield's mother found him discarded reading material from town, including old newspapers and magazines. In the *Pittsburgh* (Pennsylvania) *Courier*, he read about a pen-pal club. He decided to join. Acquaintances he made through correspondence helped him escape the confines of his rural home to touch places like Baton Rouge, Louisiana; Ocala, Florida; and Camden, South Carolina. One correspondent, a white lady, shipped him a crate of oranges from her orchard. Another inquired about his art. In return, he shared snippets of rhyming sentences he called poetry and small drawings he said illustrated his life.

The more Mayfield's psyche improved, the more his artwork expanded in scope. The *L*-shaped farmhouse became his gallery, a myriad of drawings hanging from the walls, other pieces adorning the yard and trees. No paying patrons called, but passersby could not help seeing Mayfield's growing mark on his homeplace.

He adorned trees in the yard with brightly colored bottles, continuing a tradition that had emerged in the Mississippi Delta among slaves, who adapted an ancient African tradition of painting empty drink bottles and hanging them to ward off evil spirits.

On the front porch were two cement statues Mayfield made in his first attempts at sculpture. One depicted Joe Louis, the legendary black boxer from Detroit nicknamed "the Brown Bomber." The other was of George Washington

Mayfield's concrete sculpture of Joe Louis, 1949

Carver, the noted Southern black scientist, educator, and humanitarian, who had died in 1943. The statues were rudimentary in form, shaped by hand, hair and eyebrows colored with shoe polish. But they anchored both sides of the home's front steps with their subjects' confidence. Each weighed about a hundred pounds and stood almost two and a half feet tall.

The statues caught Stuart Purser's eye while he was driving around Ecru on a rural sightseeing trip one summer afternoon. Purser was by then the new chairman of the fledgling Art Department at the University of Mississippi, the flagship state school located in nearby Oxford, almost forty miles of two-lane highway to the east of Ecru. The day was Saturday, and Purser was looking for inspiration for his own creative work.

After graduating from Louisiana College, Purser had studied at the Art Institute of Chicago. His father had wanted him to become a doctor, but his goal was to be an artist. He had left for Chicago in 1929 with fourteen dollars in his pocket and slim prospects of becoming a professional painter because of the Depression. He liked painting rural landscapes. Most of the people in Purser's paintings were black, not white. He rarely if ever attempted anything of a contemporary nature, despite the pressure in the art scene to transcend boundaries.

In England, abstractionism proliferated. In America, art melded with commerce. But Stuart Purser painted the struggles of the black man.

He worked four jobs to put himself through art school, cleaning floors and bathrooms at the Art Institute and night-clerking at the Palmer House Hotel on East Monroe Street in downtown Chicago. During his final year of school, he met a fellow student named Mary May. She had won a full scholarship but decided to split it with her twin sister, who had finished second in the

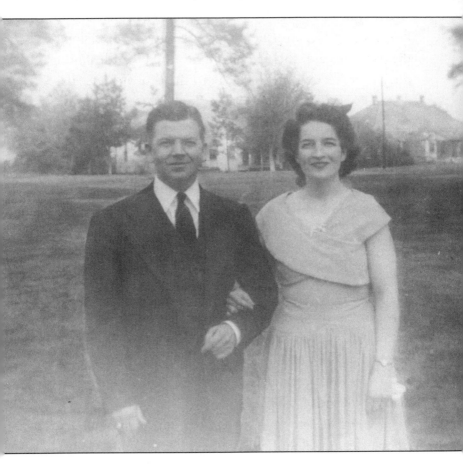

Stuart and Mary Purser

competition. In 1934, she and Stuart Purser married, paid a hundred dollars for a Model A Ford, and drove it to the West Coast, where he taught painting and drawing at Washington State University.

One year later, he and Mary moved to Louisiana so Purser could head the Art Department at his alma mater, Louisiana College in Pineville. He taught classes in painting, drawing, and history, while Mary taught design. Both practiced professionally. He preferred oil on canvas, she egg tempera. They lived on campus and had a son. They seemed a model young couple for starry-eyed students dreaming of families of their own.

The Southern Baptist–run school had not changed much since Purser's student years. Most students held hymnals in higher regard than beer bottles. Long skirts and early curfews predominated. If God did not speak audibly on rights and wrongs, He did not have to. The Bible would surely tell students what to do.

Blacks were not allowed to enroll. Young white men with well-combed, slicked-down hair and young white women with high dress necklines liberally used the word *nigger* because they knew no better.

But Stuart Purser did.

He won first prize for three consecutive years—from 1942 to 1944—in the annual Art Association Exhibition in New Orleans but never officially received the honor the last time. The mayor of New Orleans refused to present the prize because Purser's winning work depicted

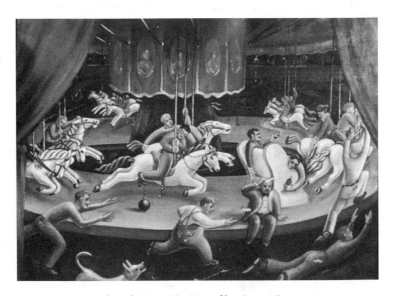

Political Merry-Go-Round by Stuart Purser

controversial, corrupt Louisiana governor Huey Long on a merry-go-round with a mistress and cronies, including one wearing a ball and chain.

Purser was chosen as an artist for the government-sponsored Works Progress Administration, which existed from the mid-1930s to the mid-1940s. He painted murals for the WPA in Alabama, Louisiana, and Mississippi. Participating artists were paid thirty-five dollars a week on average. Their works adorned public places like post offices. In Leland, Mississippi, a small Delta farming town, he painted a mural depicting blacks waiting in line on trailers filled with picked cotton for ginning at the local mill. In Gretna, Louisiana, he painted a mural of steamboat river traffic.

Mary Purser painted murals, too. Her tempera-based work in the Clarksville, Arkansas, post office showed horses with cloven hooves. Locals objected so strongly that she made a return visit to correct the error.

In the mid-1940s, the Purser family moved to Chattanooga, Tennessee, where Purser began the fledgling Art Department at the University of Chattanooga (now the University of Tennessee at Chattanooga). The city was near Purser's father's home in Rhea County. The East Tennessee river valleys and hill country made good mining for artists. Stuart and Mary had a daughter.

Purser was chosen as an artist for a Pepsi-Cola exhibit that originated in New York and traveled to the Corcoran Gallery in Washington. First Lady Eleanor Roosevelt

purchased one of his paintings for a gift to an Australian museum.

Opportunity called again in 1949. This time, the family of four moved to the rolling hills of North Mississippi, where Purser accepted a job as chairman of the new Art Department at the University of Mississippi.

Since the late 1800s, the university had been known affectionately as Ole Miss, a name that recalled the way slaves referred to the mistress of the house when distinguishing her from other women on the plantation. By the middle of the twentieth century, it was a proud institution and a living symbol of white Southern nobility.

Mississippians sent their children to Ole Miss for education but not enlightenment. The school served as a beacon of protectionism for the state's white supremacist leadership, which did not want integration at any level. As a result, faculty members were encouraged to teach ideas but not ideals. Parents did not want their children coming home to work on the family farm or in the family business with notions that would call into question the hierarchical places of whites and blacks. Whites deserved the front rows, blacks the back rows. Whites went in one door, blacks another. White students went to Ole Miss, black students to Jackson College (later Jackson State College and now Jackson State University) or elsewhere with their own kind, if they were lucky enough to go at all.

Gentility reigned and insensitivity ruled.

But Stuart Purser had not attended Ole Miss as a student, nor did he subscribe to such rules. He had long ago learned to question the pedestal upon which Southern whites placed themselves. His liberal conscience was not comfortable with pedestals.

Still, the beauty that bathed Ole Miss was irresistible to Purser and many others who fell under its spell. On fall Saturdays, nationally recognized football teams played on its gridiron while impeccably dressed undergraduates watched. Ole Miss taught the cream of young Mississippians. The university was a rite of passage, helping boys become men and girls become women, providing them a blend of education, social graces, and status, instructing them in the rights of birth and the benefits of articulating loud and clear the simple words, "Yes, ma'am" and "No, sir." Ole Miss taught its students law, medicine, business—and now art.

The year before Purser's arrival, the university had enthralled fans at halftime of a football game by unfurling the world's largest Confederate flag while the band marched onto the field playing "Dixie," the unofficial anthem of the Confederate States during the Civil War.

> O, I wish I was in the land of cotton,
> Old times there are not forgotten,
> Look away! Look away! Look away! Dixie Land.

Ole Miss was the gown that clothed the adjacent

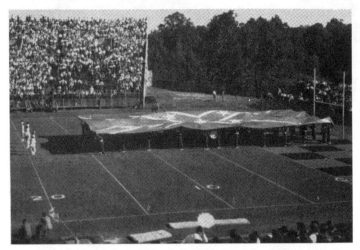

Giant Rebel flag on display at Ole Miss football game

town of Oxford. Boasting a small town square outfitted with a hardware store, a grocery store, two jewelry stores, a couple of pharmacies, a large department store, clothing stores, and a county courthouse in the middle, Oxford had about four thousand residents, less than 10 percent of whom were black. It had more Ph.D.'s and less crime per capita than any other incorporated town in Mississippi. The sale of liquor and beer was not allowed, forcing those who imbibed to drive to a nearby county.

Featuring tall magnolias, columned sorority houses, traditional brick academic buildings, and the large grassy Grove, the university had fewer than four thousand students. None were black, but blacks did work for the school in various janitorial and food-service positions. The prominent campus cheer, "Hotty Toddy," asked the

question, "Who in the hell are we?" which was followed by the proclamation, "Ole Miss, by Damn!" The campus newspaper, the *Mississippian*, was more noted for frank insights and reporting than was the local newspaper, the *Eagle*. The school cafeteria was where townsfolk dined after Sunday church services. The lemon meringue pie was always exhausted first—usually by the Methodists, who got out the earliest.

Faculty members lived in the town, and townsfolk worked at the university.

One could easily walk from the center of campus to the center of town without breaking a sweat, as long as the weather was not unusually warm. Tree-lined University Avenue connected the two entities like an umbilical cord. Simply put, most people in Oxford were not part of one without also being part of the other.

The Purser family found the setting enviable. Sometimes—like Sunday mornings, when the churches overflowed, and weekday afternoons, when the town square was filled with patrons and the campus sidewalks were thick with foot traffic—Oxford and Ole Miss felt like the very center of the universe in spite of its small size.

But Purser was equally intrigued by the bucolic countryside he had discovered when making his initial trip to Oxford. Devoid of college professors, starry-eyed, well-dressed students, and idealistic mission statements, the less traveled roads of rural North Mississippi served as a reminder of life as it had been in LaSalle Parish, Louisiana.

He was compelled to return, seeking inspiration for his work. One nearby crossroads town in particular caught his attention. On his first free Saturday following the move, Purser set out by car for Ecru.

When painting, he was drawn to the pale brown color of unbleached linen. Now, he had found a town whose very name was his chosen hue. Ecru was hardly the center of the universe, but rather a more obscure part of the galaxy that reflected a softer light.

Purser walked Main Street. He stopped his car along roadsides, peering across the fields. And then he saw a frame house surrounded by a small cotton farm. It was decorated like no other house he had ever seen. The bottle tree first grabbed his attention, causing him to slow. The concrete statues of Joe Louis and George Washington Carver pulled him in.

He drove slowly into the dusty driveway and eased his car to a halt. He opened the car door, closed it behind him, walked to the front door of the house, and rapped it with his knuckles.

An elderly black woman answered.

"I'm sorry," Purser told the woman, Mayfield's mother, "but I could not help noticing the artwork. I am an art teacher, and this is very interesting."

"My son M. B. did it," the woman said. "Come inside. He's here. You can meet him."

She walked Purser into the house and pointed out Mayfield's sketches hanging on all the walls. She headed out

the back door and stood in the open breezeway. M. B. was near the railroad track, grazing the family cow, Old Star.

"Son, someone here wants to meet you!" she called.

Mayfield left the cow and hurried to the house. He was twenty-six years old and had been practicing art since he was a child, but no white person had ever inquired about his work. He had never even met an artist.

He extended a hand to Purser in greeting, shook softly, raised his eyes from the floor to the visitor, then lowered them again.

Purser asked Mayfield to tell about each piece, how he had drawn it and why. Mayfield pulled out his sketchbook, and Purser turned the pages with him, listening to Mayfield explain how he had taught himself without lessons, adequate supplies, or education beyond the seventh grade. Mayfield told with a hint of apology about making his own paints and painting on shirt cardboards. He was not sure the work was any good, but it was his nonetheless.

"Many of my art students at the university do not do as well as you, even though they have adequate materials and some instruction," Purser said.

Mayfield smiled.

Purser also saw on some of the sketchbook pages copies of poems Mayfield had published in the *Memphis Commercial Appeal*. Printed in Paul Flowers's "Greenhouse" column, the poems all bore a name other than Mayfield's.

Purser asked why.

"Because I did not think they would publish them if they knew they were written by a black man," Mayfield said.

"Perhaps I can help you," Purser said.

Purser was intrigued that a young black man with a middle-school education had such natural talent and inclination. Imagining what might be possible with formal instruction, he wanted to provide the opportunity.

From his car, Purser retrieved art supplies he had brought along for his own work on his day trip. He gave them to Mayfield, who was delighted with the paints, brushes, and canvas. Before leaving, Purser made a more substantial offer to Mayfield.

Housed on the third floor of Peabody Hall on the Ole Miss campus, the new Art Department needed a janitor to clean the floors and bathrooms. The Art Department was also opening a gallery just off campus to display and sell the work of students and professors. That building would need cleaning, too, and an attendant. It also had a one-bedroom apartment with a small kitchen.

"Come work for the Art Department as a janitor, and I can teach you art in my spare time," Purser said. "The job does not pay much, but you won't need much. We have a room for you. And you won't have to pay for class, since they won't let you enroll anyway. But I can teach you properly."

Ole Miss and Oxford were just forty miles to the west, but they seemed a world away. L. D. Mayfield used

to travel to Oxford for appointments with Dr. Guyton when his eyesight was failing, but M. B. had never been there. The invitation was positively frightening. He had not left the house much at all in more than eight years, and he had never spent a single night away from home. The idea of moving away from his mother's care and the trusted confines of the farm was intimidating.

But Mayfield did not waver in accepting the invitation, believing a one-way trip down the two-lane highway from Ecru to Ole Miss and Oxford was just the ride he was longing for.

"Momma," he said, "I'm moving to Oxford."

Though the fall 1949 session at Ole Miss would not begin for another two months, Mayfield was elated by the job offer and the invitation to learn. Colors looked brighter. Laughter came easier and more often. Angst became anticipation.

In August, he received a letter from Purser formally offering the job. Purser included bus fare for the trip from Ecru to Oxford, along with directions to the Art Department on campus.

On a Monday morning in early October, Mayfield's mother took him to meet the bus. Carrying all his clothing and possessions in one suitcase, he boarded and followed the sign for colored passengers, which led to the rear. He took a seat in the back of the bus, facing a curtain that closed the interior into two distinct sections for whites and blacks. The curtain kept one section from seeing, and

smelling, the other. Mayfield noticed, but his racing heart never slowed.

He had never before ridden on a bus.

The ride to Oxford included two stops to pick up more passengers and took almost two hours. Mayfield was mesmerized by the up-and-down motions of the bus as it climbed one small hill, descended, and climbed another. It felt like an extended carnival ride. At one point, he began counting swales, but the total number somehow escaped him.

And then the bus pulled into Oxford, stopping at a red light. When the light turned green, the bus drove down University Avenue, past columned homes and tall oak trees, past a sign welcoming visitors to Ole Miss, and across a bridge over a railroad track before coming to a halt in front of the George Peabody Building, which housed the Art Department.

Mayfield got off the bus, retrieved his bag, and stood facing the biggest building he had ever seen. Three stories tall, with wide concrete steps leading to heavy front doors, Peabody seemed to push against his chest. He could not get a full breath. His palms were sweating. He clasped both hands tightly around the suitcase handle. He entered the building, climbed to the third floor as Purser's directions instructed, found a door, and opened it.

A class was in session, but it was not Purser's.

"I'm so sorry," Mayfield said. "Excuse me."

His stomach clenched. Blood raced to his face. He closed the door.

Mayfield tried another door.

Wrong.

And another door.

Wrong.

He wanted to turn and leave, but he did not have a return bus ticket.

He tried another door.

Inside, Purser was conducting a drawing class for a handful of students seated in a circle. When Mayfield appeared in the open doorway, Purser's face broadened into a smile. He walked away from the students and over to Mayfield, shaking his hand firmly while simultaneously patting him on the shoulder.

"Welcome to Ole Miss," he said.

"Thank you, Dr. Purser," Mayfield said, oblivious that Purser did not have a Ph.D.

Mayfield sat in the back of the room while Purser finished his class. Afterward, they walked to Purser's car. Purser drove from campus down University Avenue and pulled up at his family's apartment. Inside were Mary and their two small children. Mary had lunch made. She welcomed Mayfield to the table, where the three adults sat eating and talking of the opportunities ahead. Mayfield had never before dined at the same table with whites, but he was comforted in the Pursers' company. His earlier

embarrassment vanished, replaced with a calm like that of a summer night's wagon ride.

After lunch, Purser drove Mayfield a short distance to show him the new University Art Gallery. Located in a gullylike dip on University Avenue just blocks from campus, the small frame structure known locally as "the Teahound" was owned by Oxford resident Mrs. Ella Somerville and leased to Ole Miss. The Teahound had been a favorite hangout for students in the 1920s and 1930s. After the university established a student union on campus, it became known as "the Old Teahound." It served various purposes before the Art Department took it over in 1949.

Mayfield smiled broadly when Purser showed him the facility. In the front was a large room perfect for displaying art. In the back was an apartment that included a bedroom and a fully plumbed kitchen and bathroom. Purser had told Mayfield back in Ecru that serving as the building's caretaker would be part of his job responsibilities. He would also be the sole resident of the apartment.

Mayfield had not expected such modern quarters. He had never lived with running water or a flushing toilet. But life for him was changing quickly, as he was learning. For the first time, he was on his own. He was in Oxford with a new job and the opportunity to learn at the most unlikely of places, Ole Miss.

From the Broom Closet

Trust in the black man and his white sympathizers should have come easier for Oxford and Ole Miss. Oxford was named in 1835 after the British university town in the hope that Mississippi would locate the state's premier institution there. After Ole Miss was successfully landed in 1848, town and university were conjoined, oak-lined avenues melding with stately brick buildings.

Oxford and Ole Miss were well established in 1949 as beacons of Mississippi, one of America's poorest and least-educated states. They were small in comparison with other flagship state universities and towns, devoid of big-city amenities like streetlights and aircraft landing strips. A romanticized tradition and a tranquility accented by suspicion prevailed. Smallness, after all, sometimes breeds doubt the way silence spurs imagination.

Established after the Civil War when freed slaves in the area fled farms to build their own community, Freedman Town was located between the university and the town square. It was a cluster of small frame homes perched off the ground upon stacked wood or concrete. Freedmen Town residents were all black. They constructed their own churches and schools. Many residents were among the blacks employed to clean and cook at Ole Miss. Most worked there for years, becoming friendly enough with some faculty members to speak pleasantries on a regular basis.

James "Blind Jim" Ivy lived in Freedmen Town and became a beloved fixture on campus. The son of a slave, Ivy was blinded as a teenager when coal tar paint got in his eyes while he was painting the Tallahatchie River Bridge in North Mississippi. As an adult, he walked the streets of Oxford and the Ole Miss campus carrying a dark cane, sporting a gray mustache, and wearing a gray three-piece suit, a pressed white shirt, and a multicolored tie topped off with a wide-brimmed black hat. When the university was in session, Blind Jim ran a small vending stand by day in the university's Lyceum building, which housed the administrative offices. The stand was later moved into the foyer of the school's cafeteria. He was a fixture with Ole Miss students. In fact, Blind Jim was the only vendor allowed to operate a small, independent food business on campus. In 1931, when the food service company that ran the cafeteria demanded that all vendors

be forced off campus, students successfully appealed to the administration, saying that Blind Jim did not "ask for charity" but made his living "honestly" without begging, and thus deserved to stay.

Ivy's five-decades-long association with Ole Miss began in 1896, when he was working a university baseball game against Texas as a peanut and candy vendor. After someone told Blind Jim that Mississippi was losing, he began loudly cheering for the home team in his deep voice. Inspired students asked him to sit with them in the stands. Ole Miss came back to win the game, and Blind Jim became a fixture from then on, bringing his unrivaled enthusiasm to sporting contests.

"I've never seen Ole Miss lose," Ivy often said.

He became known as "the dean of the freshman class" at Ole Miss. Each year, adoring students purchased him a new suit, including one all-white outfit. Ivy's visibility was so great that, over time, his likeness was adopted for the university mascot. When students voted in the 1930s for a new school nickname, Rebels was selected. Within two years, the cane-carrying, suit-wearing Colonel Rebel became the central Ole Miss image. The Colonel Rebel caricature was white, of course, but everyone knew it was Ivy down to every detail but his black skin.

By the time M. B. Mayfield arrived at Ole Miss, Blind Jim Ivy was known throughout the town. He befriended everyone he came into contact with. People warmly called out his name as he stood on street corners or attended ball

games. But five decades of Blind Jim had not changed the way many whites viewed blacks. They maintained their reasons for distrust, passing them from one person to another like an airborne disease in a crowded room.

They pointed to the cook on campus caught stealing bags of food from the cafeteria. And the young black man who robbed Oxford's taxicab driver. That story was the lead in the town's paper.

"Police are looking for Albert Blackmon, well known 18-year-old Oxford Negro, who is believed to be the pistol-user who took Radio Cab Gundy Slaughter for a long ride last Sunday morning which climaxed in a stickup on a lonely country road," the story read.

"I should have been more suspicious," the taxi driver told the newspaper.

Such reports served to reinforce conventional wisdom.

Give a black an inch, he'd take a mile.

Or give a white who thought blacks deserved equal opportunities an inch, he'd eventually take away the whole hierarchical system, which seemed to be working just fine, thank you.

William Faulkner fell into the latter category. He had moved to Oxford with his family in 1901, just before he turned five. Faulkner tried his hand at poetry and drawing in grade school, dropped out of high school without a diploma, changed the spelling of his name by adding a *u* because he thought it would help him get an appointment

to the Royal Air Force of Canada during World War I (which it did), enrolled at the University of Mississippi, wrote stories for the campus newspaper, dropped out after three semesters, got fired from a job as the university's postmaster, was removed from his role as scoutmaster, lived in New Orleans, lived in Paris, sold books in a store in New York, became a published poet, and ultimately settled back in Oxford, becoming a well-published writer. By 1949, the five-foot-six Faulkner, married and the father of a teenage daughter, stood as one of the world's most renowned authors, yet most Oxford residents and professors gave him only shrugging credit, considering him more a problem than a solution.

Faulkner had started out innocently enough, writing about subjects most locals could accept, since his work was based on distant characters. But beginning with his third novel, when Faulkner followed the advice of a literary friend to mine his home people and territory, Oxford residents grew skeptical, if not outright dismissive of his work. *Sanctuary* became Faulkner's best-selling work to date in 1931. The novel depicts the rape and killing of an Ole Miss coed by a sinister bootlegger, which disgusted many locals.

Faulkner changed the names of Oxford and Lafayette County to Jefferson and Yoknapatawpha County, but no one was confused over where his inspiration came from. He used his hometown as a research library, walking to the town square from his nearby decrepit antebellum home,

which he named Rowan Oak after a Scottish legend about the protective power of wood from the rowan tree. At the square, he questioned citizens about their lifestyles and experiences. Faulkner did not seek out peers. In pursuit of information he did not already know, he avoided most whites in favor of discussions with blacks. He asked short questions, posing with one hand under his chin, fingers crossing his lips and touching the tips of his mustache as he contemplated the responses. Then he scurried back home as if he had procured something requiring immediate attention.

In *Light in August*, published in 1932, and subsequent works including *Absalom, Absalom!* he fully explored the issues and divisions between Southern blacks and whites. Over the course of a single decade, Faulkner's distinctive style elevated him to a writer of world renown.

His career languished for some years afterward. He traveled periodically to Hollywood for screenwriting stints and to a North Mississippi sanitarium for drinking-binge recoveries. Many in Oxford and at Ole Miss didn't mind the stagnation. Perhaps the world was not so ready for literary racial conflict at their expense. Besides, Faulkner drank too much whiskey, migrated toward rogues, and rarely went to church, even though three good options were within three-quarters of a mile of his home.

Faulkner accepted an invitation to be a visiting lecturer in the Ole Miss English Department in 1947 but found himself embroiled in controversy when it was

reported he disparaged fellow writer Ernest Hemingway, suggesting Hemingway "has never used a word where the reader might check his usage by a dictionary." The same year, members of the Ole Miss faculty voted on awarding Faulkner an honorary University of Mississippi degree.

The vote failed.

A confluence of events in the middle of the twentieth century permanently changed Faulkner's relationship to Oxford and Ole Miss. *Intruder in the Dust*, published in 1948, became the writer's best-selling work ever. Set in rural Mississippi in the 1940s, the novel tells the story of a black man unwilling to kowtow to whites who is found standing, pistol in hand, over the body of a dead white man. An angry white mob wants to lynch the man. When the town's most prominent lawyer refuses to defend him, he has to rely on a teenage boy for help.

MGM paid Faulkner fifty thousand dollars for film rights. Producer and director Clarence Brown made the Hollywood movie *Intruder in the Dust* in Oxford in 1949. Nearly the entire film was shot on location. Just six scenes had to be filmed in studio settings. So intent was Brown on making the film realistic that he refused a trained rabbit from Hollywood for one scene in favor of a wild, captured Lafayette County rabbit.

More than five hundred townspeople including Mayor R. X. Williams, Jr., were extras in the film. Other citizens waited on corners for glimpses of actors like David Bryan, Claude Jarman, Jr., and a striking star on the rise named

Will Geer. Everyone thirsted for stories related to the filming, including Sunday-morning church visits made by stars, poor acting by inexperienced extras, and the number of blacks shown in the film. Reported the town newspaper, "Lafayette County, Mississippi proved to M-G-M producer Clarence Brown its historic contention that it is the most Anglo-Saxon spot in the entire United States. Among the hundreds of Oxford citizens who appear in *Intruder in the Dust*, scarcely six [blacks] can be found!"

Puerto Rican star Juano Hernandez, said by the local paper to be "one of the finest Negro actors of his day,"

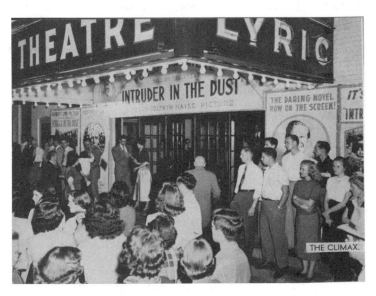

The Lyric Theatre in Oxford decked out
for the *Intruder in the Dust* premier
COURTESY OF COFIELD COLLECTION, SOUTHERN MEDIA ARCHIVE,
SPECIAL COLLECTIONS, UNIVERSITY OF MISSISSIPPI LIBRARIES

played the movie's lead role of Lucas Beauchamp. The local newspaper printed a feature story about him, stressing that Hernandez had learned during his Oxford stay how false "most of the northern publicity about Southern racial conditions" was. The story noted that Hernandez agreed to follow the "natural pattern" of segregation in Oxford, staying during filming in the home of G. W. Bankhead, the "successful negro undertaker." Hernandez's quarters were said to be as comfortable as "could be found in most of the white homes."

Hernandez was taken by Mayor Williams on a tour of Oxford's black high school, which the paper reported had "as fine a building as do the white schools." He was told by the mayor that he did not—as he had apparently wrongly heard—have to take off his hat when entering white-owned local stores. The actor bragged in the story of the food he ate at the undertaker's home, noting that the biscuits and "greens with fat meat" might expand his belt size. The newspaper summed up Hernandez's experience as proof that, in Oxford, "negroes and white men work closely together in all fields of endeavor and enjoy the same mutual respect and affection."

M. B. Mayfield's biggest fear was not holding up his end of the deal with Stuart Purser. Pushing a mop, rolling a water-filled bucket along tile floors, and swabbing bathroom sinks and toilets in a high-ceilinged building among friends were so much easier than plowing fields with a mule in the hot sun that Mayfield was uneasy with

his three-days-a-week job as Art Department janitor, wondering if his work was enough. The living quarters, the job, and the opportunity to learn at an all-white university when he had not even gone to high school were too good to be real.

"Can't I do more?" he asked Stuart Purser.

"Just do your job," Purser said, "and then enjoy yourself. Enjoy the experience."

For years, Mayfield had barely strayed from home except for church meetings and visits to the movie theater. But in Oxford, he left his apartment at the Teahound at most any opportunity to soak in the community's sights and sounds. He enjoyed watching from a distance Oxford and Ole Miss's unique blend of big and small, important and unimportant.

When he walked the several blocks to the town square in the evenings, Mayfield watched the daytime bustle slow to a nighttime crawl. By dark, most businesses on the square were closed and most country folk in town to shop for the day had long ago headed home. The doors to Oxford's movie theater and cafés opened and closed for another couple of hours as university folk wound down the day, but mostly the town's business hub grew placid after sundown.

When Mayfield walked several blocks in the other direction as Coach Johnny Vaught's Ole Miss Rebel football team took the field on fall Saturday afternoons, he saw more people gathered in one locale than he had

ever witnessed before. The population of Oxford doubled within hours as young men in jackets, ties, and loafers and young women wearing their newest dresses and heels moved together toward the stadium just before kickoff. Mayfield thought the fans could well be going to a church affair.

Football had not yet become religion at Ole Miss in 1949, though it was well on its way. An honor student and All-American guard at Texas Christian University, Vaught had taken an assistant coaching job at Ole Miss in 1946 after serving as a lieutenant commander in the navy during World War II. His relationship with the university was love at first sight. When Harold "Red" Drew left Ole Miss for the Alabama head coaching job in 1947, Vaught took charge of the Rebels. He had a fatherly, disciplined approach with players, a modern offensive style, and a recruiting plan to build Ole Miss into a national power.

The Rebels wore colors adopted at the turn of the twentieth century, a combination of blue copied from Yale and crimson copied from Harvard. Vaught's Split-T offensive formation used well-timed rollout passing to exploit defenses designed to stop the run. Ole Miss thereby gained an advantage in recruiting, as the exciting style appealed to high-school stars in the region.

Seizing upon the reputation of Ole Miss as the darling of deep Dixie, Vaught was among the first coaches to hire a full-time recruiting coordinator, whose sole job was to evaluate talent from Mississippi and the fringes of

Louisiana and western Tennessee and to maintain constant contact with high-school coaches. The Rebels won eight games and lost only one in 1948. Enthusiasm was at a previously unseen level at the time of Mayfield's arrival.

In 1949, the team wore plastic helmets for the first time ever. They were royal blue with a thin red center stripe. Vaught's Rebels adjusted slowly to newly mandated platoon rules that made depth a problem for the Mississippi team. The squad finished with a 4–5–1 record, Vaught's only losing season. But excitement in the program mounted nonetheless. For the first time, the games drew more attention than the traditional Lafayette County farmers' market, which had long attracted throngs of locals to downtown Oxford on Saturdays.

Halfback John "Kayo" Dottley thrived in Vaught's open offensive sets, leading the nation with 1,312 rushing yards and becoming a university icon. Whenever Dottley or the Rebels scored a touchdown, the crowd and the marching band erupted in renditions of "Dixie" and the school's trademark "Hotty Toddy" cheer. Blind Jim, typically the only black in attendance at games, helped lead the call.

> Are you ready?
> Hell yes!
> Damn right!
> Hotty Toddy, Gosh almighty
> Who in the hell are we?

Hey!
Flim flam, bim bam
Ole Miss, by Damn!

Pride in tradition and a growing sense of prowess were at an all-time high in the university's 101-year history, sentiments closely matched just blocks away in Oxford. No longer was the season's largest melon the biggest news of the day. In Mayfield's third week in town, Oxford hosted the world premiere of *Intruder in the Dust*.

The mayor called an official town holiday for the film's first showing. Three days of events were planned around the premiere so citizens could see "Oxford's own movie" before anyone else. The once-maligned Faulkner became the toast of the town. Not only had he written the book, he'd even agreed after considerable persuasion to advise producer Clarence Brown on script adjustments and shoots. Without Faulkner, Oxford would not be in the film.

His complicated personality, however, almost threw the premiere into disarray. Known at times as shy, at other times as brooding and aloof, and at still others as eager for the limelight, Faulkner decided he would not attend the opening of *Intruder in the Dust*, leaving the celebration to his fellow citizens. He liked the film, believing it was as true a reflection of his work as Hollywood could muster. But he did not relish the circus atmosphere. Panicked that Faulkner's absence might be taken to mean he did not embrace the film, Brown appealed to family members for

help. They persuaded Faulkner's aunt in Memphis to ask him to escort her to the premiere. He obliged at the last minute.

The festivities began on Sunday night, when rotating nine-million-candlepower navy searchlights lit up the town square. The next day, the city staged an eleven-float parade that began on the Ole Miss campus and concluded on the square. As part of the "mammoth" parade, as it was described by the local press, MGM awarded a three-hundred-dollar prize to the float that best depicted the New South. The Rebel band marched in the parade. So did the University High Band, representing Oxford's white high school. The band from the town's black high school was not invited. Mayfield walked from his apartment at the Teahound to stand alongside University Avenue amid the throng of local residents and university students as the bands and floats paraded by.

Tuesday was premiere day. Two dozen journalists, including film critics and reporters from large daily newspapers, were treated by Mayor Williams to a press-only screening in the seven-hundred-seat Lyric Theatre. MGM officials feared that the reactions of local people upon seeing themselves on film might negatively influence the journalists. Citizens were encouraged to attend the public premiere, however. They quickly claimed all available tickets—which cost $2.60—on a first-come, first-served basis. Oxford officials were able to keep tickets

in the hands of mostly local white residents.

Though Mayfield could not get a ticket to the premiere, he walked to the square and stood in the dozens-deep crowd outside the theater. His hands trembled in excitement as stars and citizens entered. Having downed a few stiff drinks en route, Faulkner made his appearance, his arm intertwined with his aunt's. As the author walked along the red carpet past the crowd gathered behind ropes, television cameras from the Memphis stations rolled, the camera of a *Life* magazine photographer clicked, the Ole Miss band in its red and blue uniforms blared songs Faulkner found "incongruously martial," and hundreds of hands, including Mayfield's, loudly clapped.

The *Intruder in the Dust* premiere was so successful that the university's student newspaper, the *Mississippian*, reported later that week that it had "turned out to be the biggest thing that ever hit Oxford, with the possible exception of Ole Miss students." The event impressed Mayfield, who wrote a letter to his mother detailing the experience of seeing Hollywood stars up close and being part of a world premiere. Nothing he had ever seen before seemed so important.

Most days in Oxford were not as exciting, of course. On Tuesdays and Thursdays, Mayfield worked at Peabody Hall on campus. Rain or shine, he made the fifteen-minute walk to and from work from his University Avenue apartment, enjoying the scurrying students and professors,

the trees, and the architecture. He wore dark work pants and a matching long-sleeved shirt that revealed the edge of his white T-shirt underneath. His hair was straightened and coiffed.

Mayfield worked from a broom closet less than four feet deep and four feet wide, where he kept both his cleaning supplies and the art supplies Purser gave him. He arranged his broom, mop, bucket, dustpan, towels, and detergent alongside his paintbrushes, drawing pencils, paints, canvases, and easel. He mopped the floors before students filed into the building for morning classes. When they learned, he learned.

The broom closet was adjacent to the classroom where Purser taught. During lectures, Purser left the classroom door open and Mayfield left the broom closet door open, as instructed. The professor's voice drifted through the otherwise quiet building.

"Add contrasting colors," Purser told his beginning students.

"Fully develop the foreground, the middle ground, and the background, and notice everything in real life and memories as art objects," he said.

Mayfield listened as intently as if he were enrolled. When the class worked on self-portraits, Mayfield did as well, revealing on canvas his tall brow and prominent cheekbones.

Often, he was invited into the classroom to operate the slide projector or pose as a model. On one occasion,

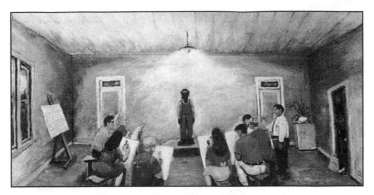

Dr. Purser's Drawing Class

the scheduled model for Purser's drawing class did not show up. Mayfield was walking in the hallway, carrying two buckets of water.

Purser called for him.

"M. B.," he said. "Can you come in and model for the class?"

Mayfield started to put the buckets down.

"No," Purser said. "Come just as you are."

For more than thirty minutes, Mayfield stood before the class, barely moving. But the full buckets weighed heavily on his arms. Sweat beaded on his brow. Purser did not notice, focused instead on the students' technique.

Desperate for relief, Mayfield spoke up meekly.

"Dr. Purser," he asked, "is it all right if I empty these buckets?"

The class broke into laughter, as did Purser and Mayfield.

Between and after classes, as students milled about, Mayfield mingled with them while setting up the projector, cleaning palettes, and arranging paints. He listened and observed. The Art Department was in its first year, and enrollment was slight. Within weeks, Mayfield knew the name of every student—Vinn Morrow, Joan Hedman, Carol Heyer, Walter Coppage, Ellen Fyfe, Barbara Cason, Sally Kershaw . . .

They knew his name, too.

Mr. Mayfield.

As he became more comfortable, Mayfield began stopping by the chairman's office to talk with Purser's assistant, Ann Woodard, and the department secretary, Zella Mae Potter. They asked Mayfield questions about his family, and he did the same with them. They sent him on errands across campus. He met the university's chancellor and deans. He became friendly with Professor John Phay, who taught art history and education. Phay gave Purser money to buy Mayfield's art supplies, making sure he had all the necessary tools.

In the late afternoons, when the students and other professors were gone, Purser met with Mayfield individually. Some encounters were merely exchanges of pleasantries, particularly during Mayfield's first few weeks on the job. Others became one-on-one art lessons, Purser explaining specific drawing and painting techniques like hatching, parallel lines to show shading, crosshatching, and rendering value scales through cross-line shading. He

also discussed the reasons people painted.

Mayfield responded that he painted to communicate.

"Words don't always come easy," he said. "Pictures do."

Mondays, Wednesdays, and Fridays, Mayfield walked but a few steps to work. He unlocked the front door of the Teahound to open the Art Department's gallery, which displayed the drawings, paintings, and sculptures of students and professors. Purser's work hung there. He had begun painting area scenes, visiting nearby Sardis Lake for inspiration and painting from William Faulkner's houseboat.

Purser had met Faulkner when he was sketching a group of blacks on the town square one Saturday afternoon during his first months in Oxford.

A stranger walked up behind him and asked a question.

"Do you always draw this kind of subject?"

Purser explained that he had been asked the question before, and that a gallery director in New York had once suggested at the closing of a show that his works had not sold because their subject matter was black people. He said the gallery director suggested that if he liked contrast, he should just paint white people against dark backgrounds.

The problem, Purser explained, was that he found blacks more interesting.

"I hear that you judged the local art exhibit at the Mary Buie Museum several weeks ago," the stranger said.

"Yes."

"Did you give my brother John Faulkner the graphic award because you thought the drawing had merit?"

Purser then realized he was talking with William Faulkner, who wanted to know if his brother's work won because it was good or because his last name was Faulkner. Purser explained that the drawing was not signed, so he had not known who the artist was, and that it was of a possum hunt, a favorite subject of his.

Several Saturdays later, Purser watched Faulkner moving around the town square speaking to country folk, white and black, who were shopping in stores and at the farmers' market.

Faulkner approached him again.

"You get your ideas and inspiration from observing these people," he said, "while I get mine through talking to them."

Faulkner made some observations on the words and expressions of blacks that Purser found interesting, though he noted that they had no use in painting. He showed Faulkner sketches he had made of blacks fishing on Sardis Dam. Faulkner said he had a houseboat on Sardis Lake that the artist was welcome to use at any time.

During trips to the lake and Faulkner's houseboat, Purser made a series of paintings he called *Ecru Lake Fishermen*. The water of Sardis Lake was yellow, reminding him of Ecru. The Atlanta Museum purchased one of the works, while another, *Ecru Lake #2*, sold to the Alexandria

Mayfield's portrait of William Faulkner

(Louisiana) Museum. Others hung in the Teahound and were acknowledged by visitors to be among the best works on display. Mayfield liked to point out Purser's work, noting that Purser was his friend and mentor.

During his days working at the Teahound, Mayfield talked with students in the ceramic studio Purser had set up. He also became friendly with the small number of regular visitors, including Blind Jim, who often came by on his daily walks to and from Freedmen Town, the town square, and campus.

Most university administrators, faculty, and students outside the Art Department were oblivious to Purser's arrangement to teach Mayfield, though word did spread among some members of the small socially conscious set at Ole Miss and Oxford. They protected the story of student and pupil, keeping it from the less approving majority by never discussing it openly.

In his apartment, Mayfield would prop a canvas against the back of a wooden chair and paint for hours some evenings. The room was dimly illuminated by a single bare bulb screwed into a ceiling socket and a kerosene lamp that sat on the fractured marble top of a dark wooden dresser. Mayfield stacked paints on the chair seat and sat in a facing chair, dipping and brushing. Among his earliest finished works was an oil painting, his first, depicting two children in warm red clothing building a snowman, a snowy field and a red, snow-covered church in the background.

On Sundays, Mayfield walked to Freedmen Town to attend Second Baptist Church. Blind Jim was a member of Second Baptist, as were Oxford's most prominent members of the black community. Mayfield was befriended by Mrs. Cecille Marshall, who operated a beauty parlor in the front room of her Freedmen Town home. She was also president of a local black women's social organization, the Silver Leaf Club, and the leading organizer of church activities. Knowing Mayfield was away from his mother's care for the first time and in the conflicted embrace of Ole Miss, she made him meals, introduced him to her friends,

Mayfield's first oil painting, January 1950

and made sure he became a part of black Oxford.

Some Sunday evenings, Mayfield dined with the Purser family, wherever they lived at the time. The Pursers moved three times in two years, one of their stays being in a faculty house provided by the university. Stuart and Mary's son, Bob, was in grade school, and Mayfield talked with him and his little sister whenever he visited, asking questions about what they liked and didn't like about school and living in Oxford. He was comfortable—more comfortable, in fact, than he had been in years. The constant activity and new environment captured his mind and dissipated the anxiety that had once dominated his life.

Purser felt he, too, was in the right place at the right time. Mary was getting a bachelor's at Ole Miss to supplement her earlier art degree. He relished the challenge of starting the Art Department from scratch, the stimulating creative environment of the town and university, his relationships with Faulkner and Mayfield, and his visits to town and the nearby countryside. Weekdays, he was a professor, chairman, and mentor. Saturdays, he visited either the town square or Sardis Lake or the rolling hills, seeking inspiration for his work.

Among his favorite Saturday events were his periodic conversations with Faulkner while citizens perused the farmers' market. Overalls-wearing farmers lined their trucks up in rows, lowered the tailgates, and peddled their seasonal produce to customers. Purser perched on

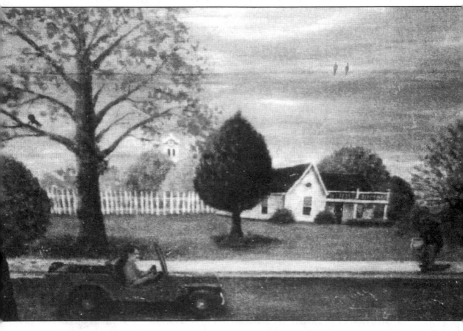

William Faulkner on University Avenue

the adjacent courthouse lawn to gain distance from his subjects. As he painted, he watched people pass, stop, browse, and sometimes buy. Meanwhile, he was always scanning the crowd for Faulkner. Purser acknowledged that he made his way to the square on Saturdays more often than he might have in hopes of talking with Faulkner, and he noticed that Faulkner seemed to be looking for him as well.

During one discussion, Faulkner broached the subject of M. B. Mayfield. The janitor's story had reached him through his wife, Estelle, who was close friends with the wife of another Ole Miss art professor.

"Does Mayfield have real talent, or is his work getting attention because he is black?" Faulkner asked.

"You could safely say for both reasons," Purser replied. "You see, Mayfield only completed the seventh grade and never had one art lesson before coming to Ole Miss."

Purser told how Mayfield had made his own paints and how he was also a poet whose works had been published in Paul Flowers's column in the *Memphis Commercial Appeal*. He explained to Faulkner that Mayfield used a nom de plume, fearing Flowers would not print the poems if he knew the submitter was black.

Faulkner said he knew Paul Flowers and that it would not make any difference to him if the author was black or not.

"Can I see the poems?" Faulkner asked.

The next Monday, Purser asked Mayfield for copies

of some published poems. He carried them around for several weeks until he again saw Faulkner on the town square.

"I've got the artist's poems we talked about," Purser said.

He showed them to Faulkner, who took a long look but offered no response.

Purser broke the silence.

"Would you say he is talented, or that they are pretty good for a black boy?" Purser asked.

Faulkner smiled.

"I think that he had better stick to art," he said.

Faulkner turned from Purser and was walking away when he stopped and looked back.

"Does Mayfield need any art supplies?" Faulkner asked.

Purser accepted Faulkner's offer of money for Mayfield's supplies, thus making the celebrated author the first and only Oxford resident not associated with the university to contribute to M. B. Mayfield's education at Ole Miss.

Chapter 5
A Harsh Reminder

When first light touched the dew-covered grassy Grove at Ole Miss in the early fall mornings in 1950, the university glistened. A new library was nearing completion. Young men wearing tightly cropped haircuts and pressed white shirts scurried to classes alongside young women with shoulder-length well-sculpted hair and knee-length dresses with proud necklines. The oak trees populating the campus reached higher than ever. Collective pride swelled, and the university basked in the splendor.

Splendor, though, can mask conflict the way a smiling face hides a broken heart. In the fall of 1950, Ole Miss suffered its first signs of turmoil.

The school term began innocently enough with the traditional activities coordinated between Oxford and

the university. A "Welcome, Rebel" party held on the town square was reported by the local newspaper to have resulted in the "biggest crowd in Oxford in many years."

Students, on the surface, did not seem dismayed by a failed town vote two weeks earlier for legal beer sales. Ole Miss student body president Maurice Danton had run a quarter-page letter in the local paper urging Oxford citizens to consider that "a vast majority" of students were in favor of the legal sale of beer, which had been outlawed in Oxford in 1944 by popular vote. In the same newspaper edition, three prominent Oxford residents, including First Baptist Church pastor Frank Moody Purser, sponsored an advertisement noting that "a bottle of beer contains twice as much alcohol as a jigger of whiskey."

William Faulkner got involved in the beer debate, responding days later with a sarcastic letter to the editor suggesting the minister had a point in his suggestion that Oxford citizens vote down legal beer sales. Oxford was already overcrowded, Faulkner suggested, so why would the town seek the economic growth that beer sales would provide? He even tried to take out an advertisement in the local newspaper against the conservative stand on legal beer sales but was not allowed to do so. Faulkner resorted to printing a broadside handbill, which he distributed throughout town.

Faulkner's pamphlet, headlined "To the Voters of Oxford," argued against the claim by local clergyman and business leaders that beer had been voted out "because of

its obnoxiousness." Faulkner argued that "beer was voted out in 1944 because too many voters who drank beer or didn't object to other people drinking it, were absent in Europe or Asia defending Oxford where voters who preferred home to war could vote on beer in 1944."

The 1950 vote failed, and Oxford remained free of legal beer sales for another two decades. Some students pointed to Ole Miss's decline in enrollment from 3,225 in 1949 to 2,745 in 1950. An editorial in the student newspaper suggested Oxford's lack of "modern amenities" was the culprit for fewer students, even though enrollment at colleges and universities nationwide dropped 10 percent on average that year, due to a smaller number of college-aged students.

In the eyes of some, legalized beer threatened the moral status of the town and the university, which prompted Oxford's conservative business community to wage war in the name of God. Newspaper ads sponsored by local businesses like the Oxford Motor Company and Elliott Lumber Company took the stance that the church saved people from evil ways.

Segregation, though, was never mentioned among the moral issues.

In his second year at Ole Miss, M. B. Mayfield was removed from such debate, which originated and proliferated in the white community. In fact, he felt more at home than he had imagined possible. Mrs. Cecille Marshall, who ran the Freedman Town beauty salon,

tried setting him up with single women, but he was not interested, preferring to spend his time with friends like herself. He sat by Mrs. Marshall and her husband on Sundays at church.

She hosted a gala-type evening reception in his honor, displaying his artwork and inviting all members of

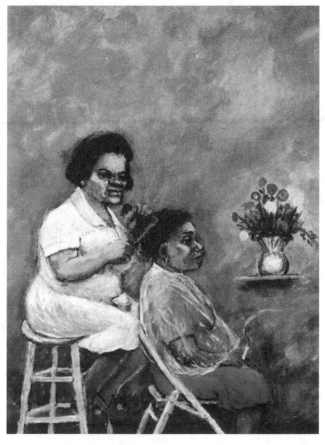

Memories of Cecille

what Mayfield termed Oxford's "elite" black community. Purser and Mary were the only white guests. Coffee and homemade snacks were served at the nighttime affair. The attendees—who included Blind Jim Ivy, members of Oxford's black school board, and the pastor of Second Baptist Church—were told about how Mayfield had come to Ole Miss to learn from Purser, who was introduced to the crowd as "Dr. Purser."

Addressing the crowd midway through the reception, Purser explained why he thought Mayfield's talent was important and why he had brought him to Ole Miss. He also said he believed people deserved the same opportunities to learn. Heads nodded in approval, but only ever so slightly. A national movement was under way through several template United States Supreme Court cases to allow blacks to enter state-funded professional programs, like law and medical schools. But everybody with knowledge of Ole Miss, whites and blacks alike, knew that such would not happen without the nastiest of fights. That Purser, the chairman of the Art Department, was attending a reception for a black janitor he referred to as a student was one thing. Actual admission to the university would be another.

Most all of Mayfield's artwork on display had been done at Ole Miss and related to his childhood days in Ecru, including schoolhouse and farm scenes. Guests purchased paintings for as little as a few dollars, giving Mayfield his first income as an artist.

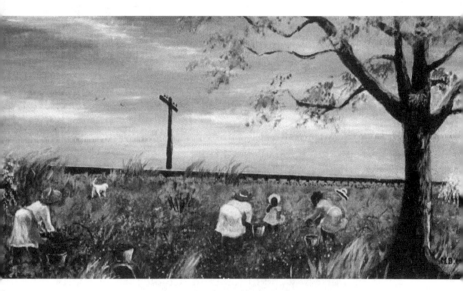

Dewberry Pickers

As he worked his way through the crowd that night, Mayfield reflected on how far he had come since Purser knocked on his door that summer day the year before. He had started painting as therapy, just to get him through the days and nights when he had been so mentally frail. Now, he was an artist selling his work and feeling better, and more stable, than he remembered.

Mayfield had considered himself an antisocial recluse before moving to Oxford and Ole Miss. But he now had so many friends that he had to recite their names to himself so he could remember them all. At the party, he greeted each of the several dozen guests by name, as if he were answering for the entire class during a grade-school roll call.

"Mr. Willie B. Tankersley," he said, extending his hand.

"Hello there, Mrs. Honey Crockett."

"Thank you for coming, Mrs. Totsie Mitchell."

The Pursers were quite comfortable at the party. The environment was different from what Stuart and Applehead had experienced in Good Pine. Oxford, though small in size, had nothing in common with similar-sized places in the Deep South because of the university. Purser was happy to see Oxford's black community embrace Mayfield. He even remarked to Mary that Mayfield might have found himself a permanent home.

He did understand, though, that he was more than a mentor and one of the biggest reasons Mayfield's experience

was working out so well. To Mayfield, he was a sort of life support system, one his student could survive away from, but not for very long. Mayfield frequently turned to Purser for assurance, advice, and approval. Purser was always there for Mayfield, teaching him in the afternoons when he worked on campus as a janitor, dropping by the Teahound other days when he manned the gallery, and inviting him home for Sunday dinners. But Purser also had a family to manage, along with job responsibilities and his own career as an artist. Building the Art Department was anything but easy.

Early in its second year of existence, the department was short on students, making recruitment and program expansion two of Purser's main responsibilities. To entice locals who wanted to learn to paint, Purser scheduled a night class in the fall of 1950. One of his enrollees was a middle-aged Oxford woman who owned a large frame home between the town square and the university that she converted into affordable apartments for students and ran as a rental business, her primary source of income.

Single and fifty-five years old when she enrolled for the art class, Theora Hamblett was a one-time rural schoolteacher who had moved to Oxford from the nearby Lafayette County community of Paris. Born in 1895 on a two-hundred-acre farm owned by her father since the Civil War, Hamblett began at an early age doing chores involving agriculture and livestock. Educated in a one-room schoolhouse, she left the farm when she went to

college, then returned to Paris to live with her elderly mother and to teach and farm. After her mother died in 1934, she focused on raising chickens but soon grew weary of the struggling business. In 1939, Hamblett left the family farm and Paris, which had two churches and just over a hundred residents. She moved fifteen miles to Oxford, where she purchased the home at 619 Van Buren Avenue and converted it into four small apartments, including the one she lived in.

The Mary Buie Museum opened just around the corner the same year she moved to town. It displayed a collection of fine art, decorative art, and historical memorabilia related to Oxford.

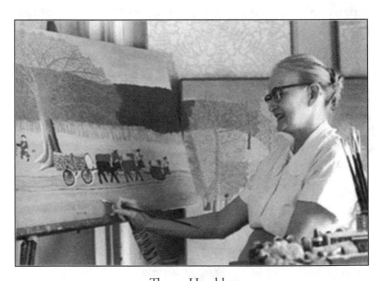

Theora Hamblett
Photo by Ed Meek
Courtesy of University Museum, University of Mississippi

As a landlord, Hamblett was home most of the day with little to do in the way of work. Since she had never liked idle time, and since she felt the spacious house needed pictures on the walls, she decided to express the vivid mental images she had preserved from growing up on the farm. Hamblett purchased paints, brushes, and canvases and began, as Mayfield had years before, a new hobby to pass the time. Through trial and error, she began painting her memories of rural life in the days when students of all ages filled one small schoolroom that had no running water, when children done with chores entertained themselves with imaginative games in the shade of tall oak trees, when farmers transported bales of cotton in mule-drawn wagons, and when the two churches were the most important places in town. She painted oil on canvas and oil on Masonite with a subtle palette.

Untrained, she signed up in 1950 for an evening class for adults at Ole Miss focusing on abstract painting. Among those she met was M. B. Mayfield, who became a friendly acquaintance. They talked about having similar styles and a shared desire to record through art a way of life as it was, according to their experiences. Most of Mayfield's works were nostalgic scenes from his life on the farm in Ecru, while most of hers were nostalgic scenes from her life on the farm in Paris. Both covered much of the same time period. Ecru and Paris were of similar size in adjacent counties, just thirty-seven miles apart. The only difference in the artists' perspectives was that he mostly

painted blacks, while she mostly painted whites.

For both Mayfield and Hamblett, self-expression was not nearly as important as the preservation of memories. Thus, she was not fond of the abstract approach. The Ole Miss painting class was the only formal training she would ever have. (She once started a correspondence course with the Famous Artists School of Westport, Connecticut, but never finished.)

The abstract class helped strengthen her conviction to paint in her own unique style, later characterized by critics as "naïve" and "childlike." She read books and magazines on painting and continued quietly illustrating memories from her childhood, including vivid trees in fall and children playing in the North Mississippi countryside amid the ever-present influence of church. Working in her Oxford home, where she turned the front den into a studio, Hamblett applied paint in heavy layers and used pointillist-like brushstrokes of primary colors to create the impression of a wider selection of secondary and intermediate colors.

As Hamblett worked in obscurity on her paintings five or more days a week while running her apartment house, Stuart Purser found allocating time to his personal work was becoming a challenge. The pieces he managed to paint were typically landscapes done on the weekends, part of an Ecru series in which he showed blacks fishing along a lakeshore.

In September 1950, one such work won for Purser

the New Orleans Prize, presented by the Art Association of New Orleans at the Isaac Delgado Museum of Art. Purser received a hundred dollars and the lead front-page story in the Oxford newspaper for his work, entitled *Ecru Lake*, an oil painting done primarily on Faulkner's houseboat.

Mary found little time to work on art at all. She was taking classes at Ole Miss and nearing completion of her bachelor's degree. Attending school full time and managing a family meant she had little room for anything else. Not being in love with life in Oxford didn't help matters.

Indeed, the Pursers were having difficulty finding the comfort they desired. The town was so small that housing options were limited. Nor could they find the right church. Since they were Baptists, Frank Moody Purser's First Baptist Church was the most logical fit. They even rented an apartment for part of one year in the back of the pastor's antebellum home, which was just up the road from the Teahound on University Avenue. But they did not particularly like either the living arrangement or First Baptist. Mary could not identify the exact cause, but she confided to her husband that she just never felt right in the Oxford church. He did not disagree.

Stuart and Mary did not drink alcohol, so they didn't care about Oxford's beer sales controversy. And they had worked for years at Louisiana College, so a conservative tone was hardly new to them. But something made Oxford and Ole Miss feel more like an extended excursion than a long-term home. Few places were more peaceful and

beautiful. Something, though, was not quite right.

University student Albin Krebs could relate. The fifth child in a family of seven, Krebs was the son of a carpenter and homemaker in the coastal town of Pascagoula, Mississippi, who dreamed as a teenager of becoming a world-class journalist. In high school, he was editor of the school paper and worked for the local *Chronicle Star* during the summers. The best journalism school in the region was half a day's drive away in North Mississippi.

Krebs's parents had not attended college. Neither did any of his siblings. He borrowed money from his parents to attend Ole Miss. As a junior in 1950, he was already editor of the *Mississippian*. To help pay his tuition and modest living expenses, he sold Chesterfield cigarettes to local stores and students. He knew how to drive a car but did not have one. He spent most of his time outside of classes at the newspaper, walking back and forth to work from his nearby dormitory.

He was an inquisitive type, eager to learn and respectful of differing opinions. He was not athletic or concerned with trying to prove his manliness. Instead, he understood and appreciated the power and value of words. In his editor's office, Krebs studied news and opinions from the larger society and tried to relate them to the small universe of Ole Miss and Oxford.

That he was a member of the university's ROTC unit would prove ironic, since it was the ROTC that wove the Confederate battle flag and Confederate uniforms into

campus culture and the obsession with Dixie's Lost Cause and the white man's struggle to hold onto ownership and heritage.

Rumblings were being heard throughout the state that "the Negro" might soon apply to one of Mississippi's coveted institutions of higher learning, like the Ole Miss School of Law. Blacks supposedly had equal educational opportunities at the undergraduate level at schools like the all-black Alcorn Agricultural and Mechanical College (now Alcorn State University) and Jackson College. But they did not have an all-black law school or medical school. And the United States Supreme Court had just ruled on a case in another state that qualified blacks should be admitted to a state professional school.

The issue of blacks crossing the higher-education racial barrier had become so sensitive in Mississippi in 1949 that Walter Sillers, speaker of the Mississippi House of Representatives, threatened to close the medical school if that's what it would take to keep blacks out. In response, the board of trustees of Mississippi's higher-education system gave college and university presidents the power to "accept or reject any applicants according to the best interest of everyone."

In other words, if a black applied, the white university chancellor or president could deny admission merely because he did not want a black student enrolled. No other reason was required. Some people knew better, though, understanding that blacks were being denied equal rights

Albin Krebs in the 1951 Ole Miss yearbook
COURTESY OF SPECIAL COLLECTIONS, UNIVERSITY OF MISSISSIPPI LIBRARIES

the fabric of Ole Miss. ROTC was mandatory for all male freshmen and sophomores, but some students like Krebs remained in the military-style activity throughout their college careers.

The ROTC unit had donned the uniforms as a sign of respect during a year-long celebration of the university's centennial in 1948. The uniforms honored the University Greys, the unit that had left campus to fight for the South in the Civil War. The Confederate apparel held such appeal for students that it quickly became part of the

and that the ways of the segregated world should and would change.

Albin Krebs certainly knew better. In the several days following an October 20, 1950, front-page article in the Ole Miss student newspaper that attracted statewide attention by suggesting that "Negroes will in the near future apply for admission to the Ole Miss law school," Krebs worked on an editorial that would alter the course of his professional life and rattle the very foundation of the university's segregated ways.

Krebs knew from reaction to the news story—which "received the amount of comment any article concerned with a possible crossing of the color [barrier] normally gets in a Southern newspaper"—that his editorial would be controversial, but he felt that taking a stand was the right thing to do. To counter detractors, he would base his opinion firmly upon fact.

"In several cases, obviously meant as tests," Krebs wrote, "the United States Supreme Court has ruled that qualified Negroes must be allowed to enter the University of Texas. A federal court has told Louisiana State University it will have to open [its] doors to Negroes. The attorney general of Tennessee has advised the university there to admit Negroes into the professional schools, with the decision being based on the recent Supreme Court findings.

"Negroes have been attending classes at the Universities of Arkansas and Oklahoma for the past two

years, and students seem to accept their presence with little resentment."

Krebs's editorial appeared in the *Mississippian* on October 27, 1950, under the headline "Stand for the Negroes. Qualified Negro Applicants Should Be Allowed to Enter Schools." He wrote that Negroes would attempt to enter other Southern universities and colleges soon and that, while Mississippi would probably be last on the list, qualified applicants "should be allowed to enter the School of Law and any other professional school that will enable them to better themselves, and thus everyone else in the state.

"It's the only answer to our age-old problem of 'the Negro.' When given the full educational opportunities he deserves as a citizen of the state and nation, the Negro will raise his own standards.

"Somehow, we feel that a great number of Ole Miss students feel much the same way about the question. We think they believe in the principles of justice for all, fair play, of the dignity of the individual. We think they believe in the basic principles of the Constitution of the United States.

"Anyone who calls himself fair or honest or a 'Christian' will find only one answer to the question of the Negroes' right to an equal education. Anyone who believes that all taxpayers have a right to the same education opportunities will agree that Negroes have the right to enter our professional schools."

Krebs wrote that "the highly emotional people who see hate when the word 'Negro' is mentioned, will immediately start, upon reading this, to get excited and call up evidence for . . . segregation," but that "regardless of what a minority of people want, the nation's highest court has ruled that in the field of education, the pigment of a man's skin must have nothing to do with the measurement of his ability.

"Whether Southerners like it or not . . . the 'professional Southerner' who mourns the death of [white supremacist Mississippi governor and United States senator Theodore G.] Bilbo and believes in an Aryan philosophy of race, will rant and shout and scream and no doubt get a lot of attention," Krebs wrote. "Let him. The fact remains that a democratic majority of the people in this country want justice and a better democracy extended everywhere, and their will will be done. And rightly so.—Krebs."

The student newspaper exploded that day like a bomb, hurling shrapnel to the farthest reaches of the state. Krebs found little support. Telephones in the governor's office rang with complaints from angry citizens, and the topic trumped others in coffee shops. Outrage even manifested itself among public-school teachers working several hundred miles away.

That was how Anne Krebs learned of the controversy spawned by her brother's editorial. A student at the all-white high school in Pascagoula, she was sitting in her American history class when the teacher began to

editorialize about Albin Krebs's recklessness at Ole Miss. He knew, of course, that Krebs was her brother. But he did not care. Her presence, in fact, seemed to incite the teacher.

"Only a fool," the teacher said, "would write such a thing."

"Blacks have their schools," he said, "and whites have theirs."

"Suggesting anything different is just stirring up trouble," he said.

"Smart people," he said, "know when to leave well enough alone."

Anne Krebs had been taught to respect her elders, but she spoke up that day to defend her brother. The teacher did not stop the taunting, however, and she never saw the man the same way again.

Damage was most severe at Ole Miss, where students threatened by such a bold editorial stance banded together against Krebs. When he walked from his dormitory to classes that day, nobody looked him in the eye. Audible mumblings of "nigger lover" came close behind. "Nigger Lover," in fact, became his new nickname. Some students let it be known that they considered him a sissified wordsmith too weak to speak for Ole Miss.

Settled quietly into his room that night after a solitary dinner at the cafeteria, he heard a commotion and looked outside his window. Burning on the dormitory lawn was a tall wooden cross. Gathered around it were more than two

hundred students, including members of the ROTC unit. They hurled stones toward his window. Shouts rose with the flames from the burning cross.

"Get rid of Krebs!" the protesters yelled in unison.

Ole Miss was engulfed in its first racial controversy.

The following two weeks proved difficult for both the university and Krebs. Many newspapers in Mississippi reported that the cross burning involved two thousand students, not two hundred. The story made headlines from Pascagoula to Jackson, but not in Oxford, where the local newspaper did not mention it at all. Ole Miss and Oxford just wanted the issue to go away, but it would not.

More than forty students signed a petition demanding a recall vote on Krebs's elected position as editor. They presented it to the newly formed student-run campus senate. And letters to the editor flowed into the student newspaper. Some took Krebs's side, but the majority attacked him. After the cross burning, and in light of the brewing statewide controversy, most faculty members who approved of Krebs's editorial kept a low profile. Some gave him quiet nods of approval, but none spoke out publicly, including Purser.

The Art Department chairman mentioned the article to Mayfield, who had little comment. Mayfield heard Krebs discussed before and after church, but members of the black community considered the issue one for whites to deal with. Blacks knew full well they deserved

admission to tax-supported institutions of higher learning. Whites had to get over the fact that the university was not 100 percent Anglo-Saxon anyway, since it enrolled international students from places like India, Puerto Rico, Guatemala, and San Salvador. But whites were not yet willing to take that step.

With the racial controversy still boiling after several days, the Ole Miss administration called in Krebs for a meeting, demanding he do something to calm the storm. The suggested strategy was for Krebs to write a clarifying editorial in the coming week's *Mississippian*, then bring the controversy to an end by dropping it. Though Krebs was not interested in backing down from his editorial, he was willing to admit his full ownership of it.

Because the editorial had been presented as the opinion of the newspaper, Krebs heeded the administration's advice and took personal responsibility for the piece. Under the headline "We Means 'I' in Editorials. Opinion Was Entirely Our Own: We Regret the Bad Publicity," Krebs described the week's events resulting from his initial editorial as "unfortunate."

"It was unfortunate in the first place that our editorial was misinterpreted by many students, who took the editorial 'we' to mean that the editor was saying everyone at Ole Miss felt as he did about the matter of Negroes entering Ole Miss," Krebs wrote.

He noted that letters pro and con on the subject were being printed in the paper simultaneously with his

clarifying editorial, but that those letters would be the last and that the subject would thereafter be dropped, since "continued discussion of the matter only adds fuel to the fire built by the outside press."

Krebs closed the editorial with this statement: "It is unfortunate that such a great amount of bad and largely undeserved publicity has come [to] Ole Miss in the past week. Perhaps it will teach all of us (cross-burners and editors alike) to use more careful judgment before taking any actions.—Krebs."

Letters to the editor appearing on the same page were less diplomatic. One writer suggested to Krebs that "if the negro race is to participate in our white democracy we must have irrefragable evidence that, as a race, they are capable of sustaining modern civilization and culture." Another writer, a physician from the Mississippi Delta town of Drew, said he found it "sickening" to have someone in such a high place as a newspaper editor "lean over backward to agitate the Negro question which might remain dormant if allowed to do so." Another detractor wrote an unsigned letter that accused the editor of being "nothing but a low down, nigger-lovin', small town hick."

Some, however, came to Krebs's defense. One was Memphis attorney Lucius E. Burch, Jr., who wrote, "Your editorial is rational, and, I think, expresses the correct view of the matter. What is of more importance, it took a great deal of courage to write it." High-school student Edith Jean Cooper said Krebs had restored "her faith in

Mississippi as a whole, and Ole Miss in particular."

On campus, Krebs found support from one of the university's more influential students, Rocky Byrd. The campus newspaper was read, but the Rebel football team was revered. Byrd was one of two quarterbacks for John Vaught's Rebels, who were enjoying unequaled popularity on campus in the midst of a 5–5 season. He was also another Ole Miss student from Pascagoula thrust into the center of campus attention. Byrd and Krebs had been high-school classmates and friends. Though they did not routinely see one another on campus, Byrd took exception to the attack, speaking up on Krebs's behalf. He told Ole Miss students to back off and leave Krebs alone. He said Krebs was "a good guy" and undeserving of the hatred and scorn he was getting.

The support made enough difference that on November 8, in a special meeting called to address the recall petition signed by forty-plus students, the Ole Miss student senate voted 43–21 in favor of dropping the "much-discussed Albin Krebs" issue once and for all.

In Oxford, dropping the discussion was never much of an issue, since the local paper had never mentioned Krebs's editorial or the resulting controversy, including the cross burning. In fact, the paper's lead story in the first edition after Krebs's "Stand for the Negroes" editorial was about a feared shortage of nitrogen fertilizer.

Two days after the student senate voted to drop discussion of Krebs, the story went away when an

announcement was made in Stockholm, Sweden, that William Faulkner was to be awarded the Nobel Prize for Literature. As only the fourth American to receive the prize, Faulkner won a thirty-thousand-dollar award and international distinction.

The news stunned most Oxford residents and Ole Miss faculty members, who were still not convinced of Faulkner's genius. Having a Hollywood movie made of a book was one thing. Winning one of the most coveted intellectual honors in the world was another. Locals who gathered at Grundy's, the diner on the town square, admitted they were surprised. They had tried to read Faulkner but could not manage to get past the first or second chapter. Now, just like that, Faulkner was being mentioned around the world in the same breath as greats like Sinclair Lewis.

One longtime Faulkner friend, Oxford's Phil Stone, mused that he remembered the years when Faulkner was "no-count," and that the writer had begun his progress toward greatness when he became interested in writing verse and started reading poets like John Keats and Algernon Charles Swinburne. The local paper questioned why Faulkner refused to "let Oxford be proud of a Nobel Prize Winner." "Faulkner was long suspected of greatness but most Oxonians did not understand," the *Oxford Eagle* reported. The Ole Miss student newspaper editorialized in a similar vein in its November 17, 1950, edition, suggesting that "Hollywood helped remind people what

genius was in our own backyard, and the world has taken notice."

Following the announcement of the award, the *Oxford Eagle* wanted an in-depth interview with the author. Faulkner, though, wondered why the newspaper had not sought such an interview earlier. He turned down the request.

"[Faulkner] does not want to be bothered," the paper reported.

Predictably, perhaps, Faulkner announced to officials in Stockholm and later to friends and family that he was not interested in attending the award ceremony, scheduled for December.

"It's too far away," Faulkner told a Swedish journalist. "I am a farmer down here and I can't get away."

Knowing that skipping such a world-recognized ceremony was not an option, Faulkner's wife, Estelle, began working on a scheme that would get him there, much as she had done for the *Intruder in the Dust* premiere.

At Ole Miss, students were less concerned with Faulkner's Nobel Prize than with the approach of one of the biggest celebrations in the university's history. Scheduled for the last week of classes before exams, the inaugural Dixie Week was intended as a fun way for students to "recapture the spirit of the old south."

Spawned by the popularity of the Confederate battle flag at football games and other campus events, Dixie Week was built around two dances, a fundraiser

that involved the selling of female "slaves" for a day of chores to the highest male bidders, and a parade. It was to culminate with the honoring of Confederate general James W. Moore at the annual Ole Miss–Mississippi State football game in Oxford.

Students and Oxford residents lined University Avenue for the parade. Students dressed in Confederate uniforms marched down the street and past the Old Teahound as if they were going to war, carrying Rebel flags and surrounding a horse-drawn carriage bearing the ninety-eight-year-old Moore, one of just six Confederate veterans still living. The parade ended at the football stadium before the afternoon game.

The day belonged to the boys in red and blue, backed by the most emotional crowd they had ever experienced. More than thirty thousand fans rose to their feet just before kickoff when General Moore was brought before the crowd in the carriage. During a halftime performance by the Rebel band, the crowd rose to its feet again when Moore was saluted by aircraft flying overhead in the formation of the battle flag. The Rebels won the game— proclaimed by pundits as the season's most exciting—by the score of 27–20 with a touchdown in the final three minutes of play.

The next week, Faulkner traveled to Sweden with his daughter Jill, a senior in high school, after Estelle devised a plan of having her tell her father she wanted to attend the ceremony with him as her graduation gift. He arrived

General James W. Moore during Dixie Week, 1951

in Stockholm after stumbling through several days in a drunken stupor.

For his acceptance speech, Faulkner dressed in a tuxedo and white bow tie—and an oil-stained, well-worn trench coat over his suit. When he addressed the audience, he did not stand close enough to the microphone, so many could not hear him. But his words easily overcame any such deficiencies. If people in the room did not hear him, many around the world certainly did.

"I decline to accept the end of man," Faulkner said

near the end of his three-minute remarks. "It is easy enough to say that man is immortal simply because he will endure: that when the last ding-dong of doom has clanged and faded from the last worthless rock hanging tideless in the last red and dying evening, that even then there will still be one more sound: that of his puny inexhaustible voice, still talking. I refuse to accept this. I believe that man will not merely endure: he will prevail. He is immortal, not because he alone among creatures has an inexhaustible voice, but because he has a soul, a spirit capable of compassion and sacrifice and endurance.

"The poet's, the writer's, duty is to write about these things. It is his privilege to help man endure by lifting his heart, by reminding him of the courage and honor and hope and pride and compassion and pity and sacrifice which have been the glory of his past. The poet's voice need not merely be the record of man, it can be one of the props, the pillars to help him endure and prevail."

The next day, Faulkner's words were printed in newspapers and broadcast all over the world. Television station WREG of Memphis, which transmitted to Oxford, showed a prime-time special on Faulkner's Nobel Prize, including interviews with some who knew the author best.

Stuart Purser watched the program and was struck by Faulkner's quiet eloquence. He was not surprised, however, at the profoundness in the author's words. The man Purser knew was not a voyeur of the South's social ills

but a compassionate illustrator who understood his ability to improve upon his landscapes. Sometimes, Faulkner was aloof, even coy. Sometimes, his voice was difficult to hear. But rarely did his words, as few or many as they may be, fail to reach previously unspoken truths.

Many in Faulkner's midst had not previously wanted to listen, bound as they were by fears and traditions. Faulkner's Stockholm remarks sent his detractors a different message. Within days of the speech, and before the author even got back to Mississippi, his words were being viewed by observers, including many former disbelievers at home, as brilliant, as words that gave hope not just to mankind at large but to people in the very small Southern places he wrote about.

CHAPTER 6
THE ART OF EDUCATION

Unexpected roads can both unnerve and tantalize a person. The urge to stop and turn around is opposed by the desire to keep going. M. B. Mayfield had traveled differently his whole life, since crawling backward as a baby. So he winced initially at the irresistible but stomach-churning opportunity offered one afternoon by Stuart Purser. If Mayfield was interested, Purser said, they would leave Oxford the next morning and drive eighty-five miles north to Memphis in search of supplies for the Art Department.

The invitation should not have caused hesitation. A few of Mayfield's friends and family members from Ecru had been to the River City and returned with tales of luxurious stores, tall buildings, and crowded streets.

Mayfield had always wanted to see Memphis. After all, some of his poems had been published in the city's daily newspaper. But he had never been given the opportunity to visit. He could not decline Purser's invitation, of course, but he nonetheless felt nervous.

The unofficial capital of the Mid-South, Memphis had attitude and a level of prosperity for whites and blacks unknown among small towns in the area. It also had a burgeoning reputation in the music world that reached far beyond Oxford and Ecru. Beale Street was a magnet for musicians. And the city's diverse radio stations, including WNBR, which broadcast its weekly *Amateur Night* show from the Palace Theater, allowed widely divergent musicians, including blacks, to perform blues, pop, jazz, and rhythm-and-blues numbers to a wide audience.

In 1948, Memphis's WDIA had hired teacher, announcer, and Beale Street performer Nat D. Williams as the region's first black disk jockey on a white radio station. Williams introduced a black-oriented musical format to replace the classical format. One of America's first stations to play rhythm-and-blues and soul music all day long, WDIA reached deep into North Mississippi. Mayfield easily picked up the AM signal from WDIA, his favorite station, on the small transistor radio he kept at his bedside. He often listened at night while he painted alone in his room, practicing the tips he had learned from Purser and other teachers and students at Ole Miss.

The opportunity to visit Memphis was a lifetime

event. Mayfield might as well have been offered a trip to New York City.

"Memphis?" said Mayfield in his soft, high-pitched voice. "Dr. Purser, are you sure that is all right?"

"I've already notified the office you will be out tomorrow," Purser said. "I will pick you up at eight in the morning at the Teahound."

"How should I dress, Dr. Purser?"

"Wear your brown suit," he said.

Because art supplies suitable for a college curriculum were limited in availability in Oxford, Purser either had to order them by mail or drive to Memphis to get them. He preferred the latter because he could examine the products firsthand and make better buying decisions. He also liked to see the city on occasion. And he understood what a trip to Memphis would mean to Mayfield. Purser knew that Mayfield's travel experience was limited and that the only art gallery outside of the makeshift Teahound display the budding artist had ever visited was the university's Mary Buie Museum. Thus, Purser's plan was to buy supplies, show Mayfield the city, and take him to the Brooks Memorial Art Gallery (now the Memphis Brooks Museum of Art), one of the South's oldest and largest museums. The gallery visit would be the highlight for Mayfield, since learning the fundamentals of art meant little without exploring and studying the works of others, particularly the world's best.

"I will drop Robert off in the morning for school and

pick you up right after," Purser said. "We will have a full day but should be back by dark."

Mayfield was waiting outside the Teahound when Purser arrived precisely on time. The drive to Memphis took two hours. The discussion focused on Mayfield's artistic progress and his experiences in Oxford and at Ole Miss. Purser asked Mayfield questions about his childhood and his hopes for the future. Purser also talked about his own childhood, sharing vignettes about the shaping of his life and art. He told Mayfield about Applehead, his father, and the Ku Klux Klan in Good Pine and explained why he preferred painting images of blacks and rural settings. Anybody, Purser said, could paint a scene of unknown children building a snowman, but only an individual artist could show his or her unique life and experiences. Even in an abstract work, an artist had to transmit his or her individual knowledge. In landscapes and portraits, the artist had the very same responsibility. Technique, Purser said, was important, but most artists could learn technique. The secret, he said, was developing one's own style and identity.

"Only you can paint what you know," he said.

Purser explained how Faulkner's work had become more respected when he began to write what he knew.

The drive went by so quickly that Mayfield was surprised when Purser announced they had reached the Memphis city limits.

"Welcome to the River City, M. B.," Purser said.

"Memphis, Tennessee," Mayfield responded, unable to hide a broadening smile. "WDIA."

Purser drove first to the six-story S. C. Toof and Company building, located on Madison Avenue in downtown Memphis. There, he and Mayfield selected art supplies for the university's spring semester classes. Purser showed Mayfield the many different types of materials available, explaining how each was best used. And he let Mayfield pick up some new supplies including paints, brushes, and canvases for himself.

They finished shopping just before lunch. Purser bought sandwiches from a local diner. He and Mayfield ate them together outside on a bench overlooking Memphis's bustling Fourth Street. Mayfield noticed that passersby barely gave them a glance, as if a white man and a black man dining together in the noonday sun was not so unusual at all. Mayfield thought they probably suspected he was Purser's helping hand—which in fact he was, so that was okay. Mayfield enjoyed not feeling conspicuous.

After lunch, they got back in the car and drove east, away from the river and toward the city's midtown.

"I have something to show you," Purser said. "I think the Brooks Gallery is one of the best in the South. Since we have the afternoon free, let's go and see it."

Mayfield knew of the Brooks Gallery. He remembered reading about it in the back copies of the Memphis newspaper he had once perused back home in Ecru.

When Purser pulled into the parking lot overlooking

Overton Park, Mayfield could not contain his excitement. After exiting the car and walking together to the front entrance of the stately four-story stone building, they stopped to read the sign that explained the visiting hours, the price of admission, and the specific days "colored" people could enter. They saw a problem immediately. They paused and checked the words again before either spoke up.

The day of their visit was for whites only. No coloreds were allowed.

The men required a few moments to absorb the realization that Mayfield would not be allowed to enter the gallery. As the uncomfortable silence grew, Purser's face turned red. He looked at the ground, then up at the sign yet again, just to make sure.

Nothing changed, though. No coloreds were allowed that day.

Mayfield's shoulders slumped. But he spoke first, hoping to calm the obviously agitated professor.

"It's all right, Dr. Purser," he said in a soft voice. "It's all right."

"I'm sorry, M. B. I didn't know."

"It's all right, Dr. Purser."

"Not really," Purser said. "No. It is not really okay. Wait here, M. B. Let me see what I can do."

Purser walked inside the museum, paid the price of his own gallery entrance, and went in search of the director.

He found her working alone in an office. Purser tapped on the glass door.

"Excuse me," he said. "Ordinarily, I would not bother you, but these are not usual circumstances. I am Stuart Purser, chairman of the Art Department at the University of Mississippi, and I have been here several times. The gallery is one of my favorites. I planned a special trip here today to bring one of my art students. He is not formally a student at the university, but he is a student of mine. He works at the Art Department, and I work with him. So do the other professors and also many students. He was so excited about the visit, but when we arrived, the sign said blacks are not allowed in on this day. Is there anything you can do?"

"I don't make the rules, Mr. Purser," the director said, "but I am in charge of the gallery. Anyone can visit as my guest. Perhaps you and your student would like to tour the museum today as my special guests."

The director walked Purser back to the front door. Mayfield was summoned inside. Purser explained that the director wanted to give them a personal tour, eliminating the concerns that might be caused by a black man roaming the museum on a whites-only day.

"Are you sure that's all right?" Mayfield asked the director, focusing his eyes on Purser. "I don't want to be any trouble."

"No trouble at all," the director said.

For more than two hours, the director walked Mayfield and Purser throughout the Brooks Gallery, showing them the range of American and European works on display, including impressionist paintings by Pissarro, Sisley, and Renoir and portraiture by the likes of Gainsborough, Reynolds, Lawrence, and Romney. Mayfield mostly listened to the explanations and left the questions to Purser, but he clung to every word with the closest attention.

At the end of the tour, the director said goodbye to Mayfield. He thanked her three times.

Purser walked with her back to the office to extend his appreciation.

"You cannot imagine how much this meant to him," Purser said.

"That's right," the director said. "I cannot imagine."

While waiting on Purser's return, Mayfield visited the colored men's bathroom, stopping on his way out for a sip of water from a fountain designated for colored use. He met Purser back in the lobby, and the men walked to the car with little discussion.

Shortly into the drive back to Oxford, Purser broke the silence with an apology to Mayfield for bringing him to the gallery on a day when blacks were not supposed to be admitted.

"I'm so sorry, M. B.," he said. "I didn't know."

Mayfield assured him that in getting a personal tour

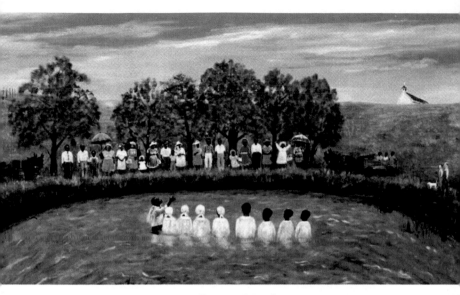

Baptism Mural

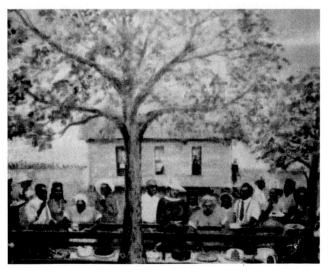

Dinner on the Ground

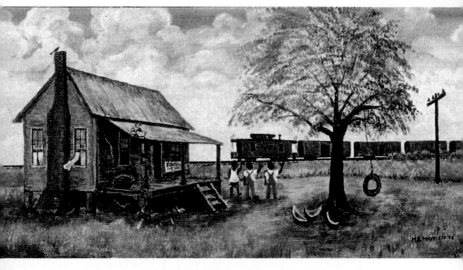

Caboose Man #2

Spain's Airplane

There Goes Faulkner

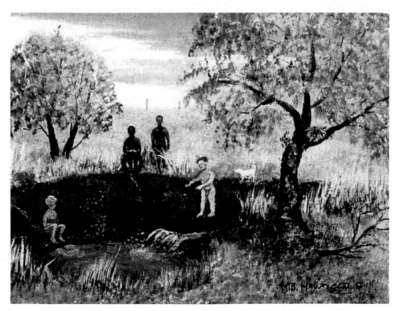

Skinny Dipping

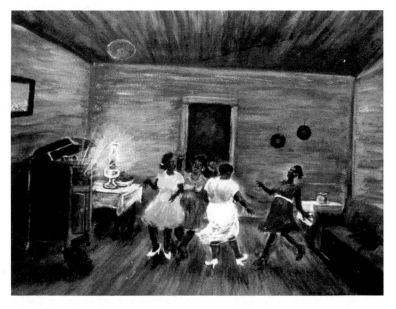

High-Heeled Saturday Night

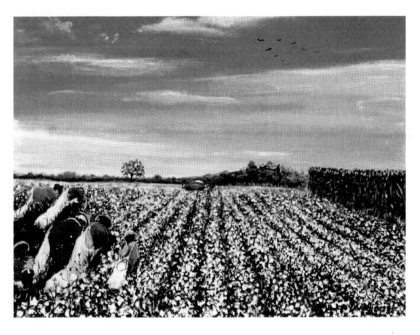

Picking Cotton in Ecru Bottom

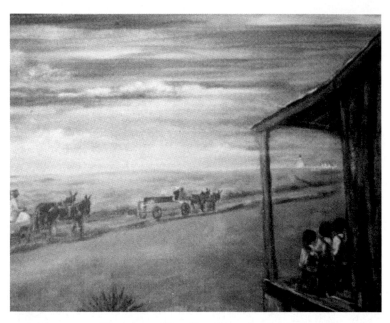

That's Papa (One Gray December Day)

Sorghum-making

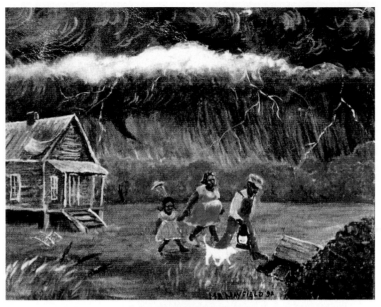

Run For Your Life, #2

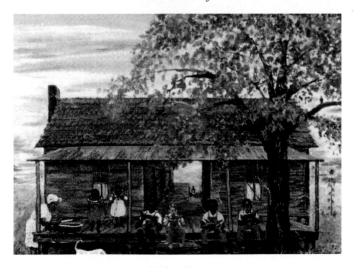

Melon Party

Chasing Fireflies by Stuart Purser

Children and Chickens by Theora Hamblett

from the director, he felt privileged, not discriminated against.

"Dr. Purser," he said, "I have never been anyplace so wonderful. And the director was so nice to give us so much time."

The ride home was much quieter than the ride up. Mayfield passed the time resting his hands in his lap and looking out the window at rolling pastures interspersed with stands of North Mississippi's indigenous hardwood trees. Memphis, it turned out, was not so far away from Ecru as he had thought.

Purser, on the other hand, held onto the steering wheel tightly with two hands all the way home, gripping one in the ten o'clock position and the other at four o'clock. While his eyes focused on the road, his mind was fixated on the Brooks Gallery sign that said colored visitors were not allowed on certain days.

Back at work at Ole Miss in the following days and weeks, Purser saw how the trip had impacted Mayfield, who spoke of the Brooks visit to anyone he engaged in more than casual conversation, mentioning the works of famous artists from around the world, telling of his personal tour from the director, and saying how he hoped to one day have a painting of his own displayed in the gallery. This reinforced for Purser something he had learned years before in Louisiana—namely, that possibility is often recognized only through opportunity. Some people were

able to create their own opportunities, while others had no chance at all without a hand from someone else. Had the gallery director not invited Mayfield in, he might never have returned. Instead, Mayfield was brimming from the experience and had a renewed enthusiasm for art.

Purser responded by taking Mayfield along as his assistant on many of the trips he made to discuss art at area colleges and universities.

Motel lodging was always an issue, since whites and blacks were not welcomed into the same properties. Typically, Purser dropped Mayfield off at one motel and paid before going to another motel. The next morning, after each had breakfast, Purser picked up Mayfield on the way to the meeting.

Restaurant dining was an even greater challenge, since they sometimes had to stop together for food on the road. Blacks were almost never allowed to sit in the same section as whites. Purser and Mayfield had to either sit at different tables or get food to go and eat by the roadside or in a park. Mayfield understood the laws of the land, unfortunate as they were, having lived with them in Ecru since childhood. He worked to make Purser's trips as easy and enjoyable as he could, never suggesting that such segregation rules were demeaning.

Ordinarily, Mayfield would not have been welcome at Purser's lectures, since blacks and whites did not attend educational activities together. They got around those rules by having Mayfield pose as the art professor's assistant,

setting up the equipment for slide shows and carrying Purser's bags and artwork into and out of meetings. Purser was not comfortable with the obvious slight, introducing Mayfield to his audiences and explaining that Mayfield was studying under his tutelage to become an artist.

The trips were a highlight for both men. Purser enjoyed the companionship, using the time out of the office to teach Mayfield everything he could about art. Mayfield enjoyed the time as well, feeling that Purser was as much a family member as a friend and mentor. He also liked the travel, since everywhere they went up and down the state was new to him.

Purser often made reference to his time studying at the Art Institute of Chicago. Mayfield was familiar with the city because copies of the *Chicago Defender*, a weekly black-owned newspaper, were regularly sent down to Ecru. Members of the black community shared the papers, learning about job opportunities in the industrial Midwest. To them, Chicago seemed a sort of oasis outside the oppressive South. The *Defender* did not use "Negro" and "black" in its stories, referring instead to "the race."

Hearing about Mayfield's desire to visit Chicago gave Purser an idea. The Art Institute of Chicago had begun promoting a Van Gogh exhibit. Having witnessed Mayfield's enjoyment of Memphis and the Brooks Gallery, Purser imagined how his student might benefit from a trip to Chicago and the upcoming exhibit. If Purser could arrange a Chicago trip, the entire Art Department could

say thank you to Mayfield for his friendship, work, and willingness to learn.

Purser began a special collection in the hope of sending Mayfield to Chicago in May 1951. If he could raise enough money, the Art Department would present the trip to Mayfield in April on his birthday.

Purser told fellow professors about the idea during a faculty meeting and students during individual meetings before and after class. All the needed money was collected in a matter of weeks. The entire Art Department faculty contributed, as did many students. The largest sum came from William Faulkner, who learned about the plan from Purser during one of their impromptu Saturday meetings.

Mayfield had no idea what was developing until many of the participating students and faculty members approached his broom closet late one morning, just after classes had dismissed.

"M. B.," Purser said, "we have something for you. We appreciate everything you've done, and we want to say thank you with this gift. We have a round-trip train ticket purchased, a hotel room reserved, and a ticket to the Van Gogh exhibit in Chicago. You are going to Chicago."

Mayfield stood quietly for a moment, covering his mouth with his right hand.

"But Dr. Purser," he finally said, "I cannot accept this. I cannot accept this. You are all too kind."

"Just consider it a birthday present from all of us, M. B.," Purser said.

Mayfield began packing his overnight bag when he got home that evening. He marked days off the calendar as they passed.

When the departure date arrived, Purser picked up Mayfield from the Teahound and chauffeured him thirty miles to the nearest train station, in Batesville. Purser waited with Mayfield for the arrival of the City of New Orleans, which ran in nearly a straight line the entire nine hundred miles from Louisiana's Crescent City to the Windy City in Illinois. Mayfield, who had never ridden on a train, was so nervous about arriving alone in Chicago and navigating the city's 3.5 million inhabitants that he did not mind sitting in the colored section in the rear or trying to sleep upright in his seat.

When the train arrived at Chicago's Loop Station just before midnight, Mayfield contemplated that he was just a country boy from Mississippi hundreds of miles from home, in a major American city for the first time. The station bustled, rail lines coming in from every possible direction. As he gathered his luggage, he was scared and exhilarated at the same time, wondering what might transpire during his three-day trip.

Mayfield consulted a map Purser had hand-drawn for him of Chicago's Loop area. It contained explicit instructions on finding his hotel, the YMCA on Wabash

Avenue. Founded in 1911 by philanthropist Julius Rosenwald, the YMCA had been for blacks relocating from the South to Chicago earlier in the century what Ellis Island once was for European immigrants to America. In 1951, the property remained a safe overnight haven for blacks traveling to Chicago, providing a welcoming, affordable, and centrally located stay.

Mayfield easily found his way to the YMCA. Chicago's streets were quiet when he walked through the swinging hotel doors. Still, all the tall buildings he had seen made his heart race and his confidence falter. At the front desk, he placed his bag on the floor and signed a check-in ticket, his hand shaking so much that he hardly recognized his own signature. In his room, he gazed out the window to see the city lights shimmer. Tired from the twelve-hour train trip, he retired to bed within the hour.

The next morning, calmed by his eight-hour rest, Mayfield showered, dressed, walked to bustling Wabash Avenue, and located a corner café that welcomed blacks. Using his meal money, he ordered a full breakfast of bacon, toast, eggs, grits, and juice while reading the map Purser had drawn for him showing the way from his hotel to the Art Institute of Chicago. But even the most carefully planned paths should be rerouted when circumstances like a warm spring day and a first-ever trip to the Windy City intersect.

It was the seventeenth day of May. The sun was shining. Not a cloud was in the sky. A tepid breeze drifted through

streets shadowed by tall buildings. And Mayfield's route diverged. He walked to Grant Park, slowly making his way through the formal, symmetrical gardens blossoming in the late-spring warmth to arrive at the edge of Lake Michigan's chilly waters. Gazing across the waves, which extended as far as he could see, he wondered if that was how an ocean might look. The clock was just past noon, and he had planned to be at the exhibit before lunch, yet the scenery beckoned him to stay.

Mayfield sat on a park bench overlooking the water, basking in the sun's hypnotic rays, until a middle-aged white man he did not know approached, breaking the spell. From his first words, the man seemed polite. Mayfield deemed him trustworthy, not the type of person Purser had warned him about. Mayfield told the man the visit was his first to Chicago, and that students and faculty members of the Art Department at the University of Mississippi and even the famous author William Faulkner had paid for the trip so he could see the Van Gogh exhibit.

"Is that right?" the man said. "Well, I was planning to see the Van Gogh exhibit myself."

When the man offered to accompany him to the museum, Mayfield accepted without hesitation. They left the park just before noon and made the short walk to the Art Institute of Chicago. They paused in the lobby, looking for ticket information and exhibit directions. Mayfield knew he did not have to look closely at the sign because Purser had already called the museum, but he could not

help himself. Experience did that to a person. Mayfield scanned the sign to make sure he was not in for another embarrassing moment. Coloreds were not mentioned anywhere.

Thank you, Dr. Purser, he thought.

Mayfield reached for his wallet to pay his admission, but the man told him to put it away.

"This is my treat," he said.

"No," Mayfield said. "Let me pay my own way."

"This," the man said, "is my pleasure."

Mayfield and the man toured the museum for more than an hour before recognizing they needed to eat. They walked together to the cafeteria. The man bought them both lunch, and they dined at the same table, collecting little more than passing glances. Afterward, they spent another couple of hours walking, stopping, and looking at canvases while the man explained the Dutch artist's post-impressionist works. Mayfield listened intently and made a silent note to himself every time he saw another black person touring the exhibit. Chicago, it seemed, was a long way from Memphis.

At the end of the tour, Mayfield and the man exchanged pleasantries and parted ways without exchanging names. They never met again.

Mayfield followed Purser's map back to his hotel. That evening, he wrote a postcard to his mother in Ecru. Addressed to Mrs. Ella Rucker, Route 1, Ecru, Miss., it read, "Dear Mother, I am having a wonderful time here in

Chicago. Wish I could stay up here. This is the picture of my hotel. So, bye, bye, M. B."

During the last two days of his stay, Mayfield entertained himself by walking to historic and important sites throughout Chicago's Loop area, visiting Soldier Field, the Museum of Natural History, and the Wrigley Building.

Late in the evening on his third day, he packed his bag and walked to the train station to board the City of New Orleans for the trip south toward home. As the train clacked along from stop to stop, Mayfield reflected on all the places he had been since Purser offered him the job at Ole Miss—places he had never imagined visiting. For so many years, exploration beyond his mother's home in Ecru had been a frightening thought. Now, he was on the move, his life satisfyingly full of possibilities.

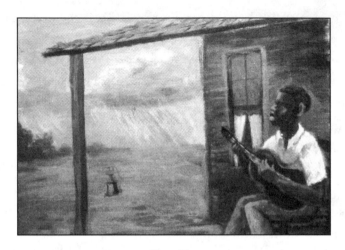

Ecru Blues

A Trip Back Home

The deepening segregationist tone and white supremacist symbolism that had emerged at Ole Miss did not dissuade M. B. Mayfield from thinking almost two years after his arrival that he had found himself a permanent place to live. He had experienced discrimination his entire life, after all, and never assumed Ole Miss and Oxford would be any different.

Still, Mayfield did not like it. His stomach churned when students donned replica Confederate uniforms or proudly waved Confederate battle flags. But he knew that the rest of the country would have to change long before

deep Dixie did, and that blacks were segregated in notable ways throughout most of America in 1951.

Seats at the back of the bus, separate schools, dirty public bathrooms, and lower pay for similar work were national problems. The Negro was a second-rate citizen of the United States, not just in one tiny spot in North Mississippi. At Ole Miss, Mayfield figured, some students were just more vocal about their feelings. Besides, he had friends both white and black. He was learning as an artist from some of the state's best teachers, traveling to new places, and meeting new people. Mayfield was gaining confidence and seizing opportunities with each passing week.

A friend drove him three hours south to Jackson so he could take the General Educational Development (GED) test, since he had not finished high school. He passed, earning the certificate. Ole Miss students invited him to show his work alongside theirs in a departmental art show. He accepted, displaying half a dozen of his oil paintings and receiving some of the highest compliments from attendees. Something new and better always overshadowed the bad. Leaving never entered his mind.

Life, however, thrives on the unexpected, and Mayfield's experience at Ole Miss would soon come to an end.

The Pursers remained unsettled in Oxford. They still had not found a long-term home or church and were uncomfortable with the prevailing racial tone on campus.

As Mary was finishing her last degree requirements at Ole Miss in the spring of 1951, Stuart learned of a job opening at the University of Florida. Like Ole Miss two years earlier, Florida was expanding its Art Department and seeking a chairman. Purser applied and quickly became a leading candidate. Though he didn't like the thought of leaving Mayfield, Purser understood that life would continue well beyond Ole Miss, just as it had after he left friends and colleagues at Louisiana College and later at the University of Chattanooga. So when the University of Florida offered him the job, he accepted without hesitation.

Among the first people he told about his family's impending move was Mayfield, his friend, employee, and pupil. Happy for Purser, Mayfield encouraged him in the move. Purser assured Mayfield he would be fine at Ole Miss without him, considering the many friends he had made and his years of self-sufficiency.

"I want to thank you for the opportunity, Dr. Purser," Mayfield said. "Thank you so much."

"Look at what you've done," Purser said. "You did this, not me. We will stay in touch, and I will look forward to seeing the works you do."

"I'll be fine, Dr. Purser," Mayfield said.

"I know you will, M. B.," Purser said.

Privately, Purser worried that Mayfield might have placed too much reliance on their relationship and that remaining at Ole Miss in his absence might prove challenging. The special trips, the subtle pats of

encouragement, and the constant presence of the man who had invited him there in the first place would be gone. But opportunity beckoned, and Purser knew the time had come to leave.

When the spring semester concluded, Mary received her bachelor's degree, Stuart relinquished his chairmanship responsibilities at Ole Miss, and the family moved to Florida, leaving behind almost three years of indelible experience. Mayfield continued his jobs for the Art Department while learning as he had before, seated in the janitor's broom closet and listening to classroom lectures through a crack in the door.

He took more interest in sculpting, talking with students and the professor teaching the class when he had the chance. He also maintained his social life, remaining a regular on Sundays at Second Baptist Church in Freedman Town and keeping in touch with friends. The adjustment in Purser's absence, he found, was not so great, for all the very reasons Purser had listed. Oxford and Ole Miss still felt like home.

Ecru was just thirty-five miles away, yet it might as well have been five hundred. Since Mayfield did not have a car, the trip required bus fare. He had thus not returned as often as he would have liked. But when he received word early in 1952, his third year at Ole Miss, that his mother was in serious condition following a stroke, he caught the next bus to Ecru to see about her. For three days, Mayfield and his brothers and sisters gathered at her

bedside, expecting the worst, since she was gravely ill.

When it became apparent she would survive, his brothers and sisters went back to their jobs and homes, but someone had to remain to care for her, since she could not be left alone. The stroke had left his mother an invalid. Mayfield remembered how she had cared for him during his breakdown and the years that followed. The decision was easy. He decided to leave his job and the learning environment at Ole Miss and move back to Ecru to look after his mother.

Life's unanticipated obstacles are often the most difficult to cross. Once Mayfield made his decision, he faced harder challenges he had not considered. In Oxford, Mayfield had been removed from the poverty he had left behind on a sharecropper's farm. In returning home, he realized he had forgotten just how tough life could be. No electricity and no running water were one thing. No bank account, no money, and no prospects for future income were another.

Before the stroke, Mayfield's mother had lived at the barest minimum, surviving on what little income she could bring in from doing chores for others and growing a garden on the property. The farm was too much to manage now that her husband was deceased and her children had gone. Someone else rented it and tended to that task. Prior to her illness, she had the house and what little money she earned. Now, she had the house but no money.

Newspapers still covered the walls of the homeplace,

but they had aged to the point that their curled edges were brittle enough to break right off when touched. Small pieces covered the dark plank floors. Mayfield swept them up when he cleaned the house as one of his chores. He also wiped bits of food from the meals he made from the corners of his mother's mouth, did all the washing and ironing, and tended the garden. He had no time left for what did not have to be done—meaning that he put aside his art to fulfill his full-time domestic and nursing role. Creative endeavors would have to wait. He was too busy, and battling once again that feeling of uncertainty, this time for a different reason.

Mayfield was almost thirty years old. Most of his peers were long gone, having headed north for jobs in Illinois and Wisconsin. Nobody much was left to make fun of him for his mannerisms and personal style. Following his Ole Miss experience, Mayfield was more comfortable with who he was anyway. He had not, however, expected to find his mother with no source of income to sustain the household and no money saved whatsoever. Having left his job to care for her, he wondered how they could make ends meet. He had saved a small sum working at Ole Miss that he had planned to spend on art supplies. Instead, he used the money to keep them fed until his mother was able to draw a small government welfare check to provide for basic needs.

A couple of years passed. His mother's condition steadily improved to the point that she could share some

of the household work and he could begin again to explore his lifetime love, art.

Mayfield applied the lessons he had learned to his newest works, revealing more depth and better transitions. He painted a still life of the limb of a blossoming fruit tree and an image of his aging mother having her hair combed and styled by the hands of his sister. One sunny afternoon, he posed in the yard with the works for a photo taken by a family member. His combed-out hair styled back at the sides and top in a pompadour like the famous actor of the day, James Dean, Mayfield had one hand clutching the back of an easel and the other holding a painting. The black-and-white shot served as proof that he was a practicing artist once more.

Meanwhile, Albin Krebs was serving his country in the Korean War as a first lieutenant in the United States Air Force. Krebs had wanted to remain in Mississippi when he graduated from Ole Miss. He applied for jobs at leading newspapers, but none wanted to hire him because of his controversial editorial stance in the Ole Miss student newspaper his senior year. Krebs instead parlayed his ROTC experience into a job with the military, becoming a press censorship secretary. He used the money he earned in the service to pay his parents back for the loan they had given him to attend Ole Miss.

Krebs had married by the time he was sent on assignment to Japan, then to Korea. His wife was pregnant with their first child. She went into early labor while he

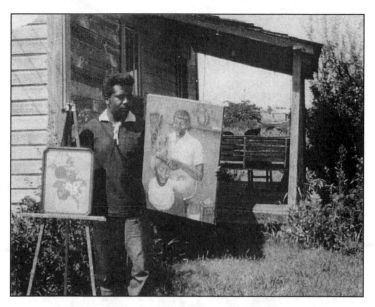

Mayfield in his yard in Ecru with two of his paintings
from the 1950s

was stationed in Korea, and both she and the baby died in childbirth. Authorities were unable to notify Krebs for several weeks.

Back in Oxford, the racial controversies from several years earlier had settled, but white supremacist symbolism remained firmly entrenched, a sign to the world that Ole Miss was a loyal keeper of the gate to Dixie's segregated traditions. Because Oxford was a university town known for its literary allure, compliments of Faulkner, and for a quaintness colored by its front porches and courthouse square, it attracted an eclectic array of visitors who otherwise would have had no use for a North Mississippi

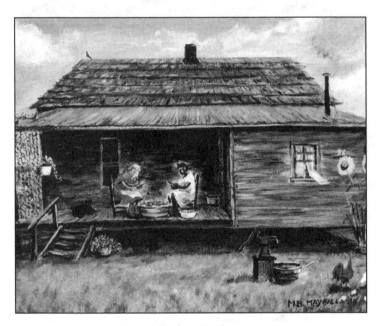

Peeling Peaches

town of less than five thousand residents. One such visitor in 1954 was a New York artist and gallery owner who was visiting friends when she learned about the unique works of a middle-aged local woman named Theora Hamblett.

Born into wealth in 1900, Betty Pierson had grown up in luxury in her family's New York, Palm Beach, and Newport homes. She was driven by a chauffeur to finishing school. At the age of twenty, she married Schuyler Parsons, a wealthy Parisian. He turned out to be a homosexual alcoholic, and the union lasted just three years. After the divorce, Betty Parsons was disinherited by her family. She remained in Paris for another decade, living on alimony while developing friendships with members of the city's older expatriate community, including Natalie Clifford Barney—a writer who hosted a popular literary salon attended by F. Scott Fitzgerald and Sinclair Lewis—and Alice B. Toklas, the life partner of Gertrude Stein.

Parsons became an artist. When her alimony expired, she moved to New York, opening the Betty Parsons Gallery in 1946. It specialized in abstract expressionism, the works of obscure artists she judged as having unusual talent, and the works of gay and lesbian artists she deemed important. By the 1950s, Parson's gallery and eye for discovery were world-renowned among art collectors.

Theora Hamblett had by then amassed a stable of folk-art portraiture done in an individualistic style. The trees she created on canvas read like Braille to the touch.

Parsons made an unscheduled visit to the four-

apartment home on Van Buren Avenue. When Hamblett escorted her into her small living quarters, Parsons knew immediately that she had stumbled upon something. So impressed was she by Hamblett's pastel colors accented by stylized dots of paint to create the leaves of trees that she did not want to leave without a painting. She purchased on the spot for a small sum Hamblett's *Cotton Pickers*, one of the artist's early landscapes. She subsequently donated it to New York's Museum of Modern Art. Parsons also signed on as Hamblett's New York agent. Though the folk artist's career took off from that moment, she never abandoned her quiet home life and her disciplined approach to her craft, working year-round on Monday, Tuesday, and Wednesday mornings and all day on Thursdays and sometimes Fridays, but never on weekends.

At the time Hamblett was discovered, Mayfield was far removed from the art world. He was, however, falling hopelessly under the spell of another emerging artist. With no television or daily newspaper for entertainment, Mayfield passed the time he worked in the home listening to the radio, turning it on when he woke up in the morning and leaving it on until he went to sleep at night. His favorite station had once been WDIA out of Memphis, which had recently increased its broadcast power to fifty thousand watts and was now calling itself "the mother of all Negro stations," blasting shows deep into Mississippi's heartland. But Mayfield was tuning in elsewhere in late 1954.

Like Mayfield, Elvis Presley had been born in

Mississippi to working-class parents. He was given a guitar as a present for his eleventh birthday when his family could not afford the bicycle he wanted. His uncle provided him lessons. Presley's family moved to Memphis in 1948, living in an apartment complex in a poor section of town. Presley was captivated by the music coming out of Memphis in the early 1950s, often hanging out as a teenager on Beale Street, known for its blues clubs. He also frequented white gospel music events that evoked the traditional sounds he had heard since he was a child.

In the summer of 1953, Presley was a high-school graduate driving a truck for a living who believed he could make it as a musical artist. He went to Sun Records' Memphis studio one afternoon and said he wanted to record two songs for his mother's birthday. What he really wanted to do, of course, was show the record company how well he could sing. So he paid the fee of four dollars per song and made two recordings. Though nothing came of his visit for another year, the young white truckdriver with the soulful sound had made an impression at the studio. And when Sun Records boss Sam Phillips was looking for someone to record a blend of black music and boogie blues, thinking whites would be attracted to the soulful style, he called in Presley to give it a try.

Presley's recording session did not go very well, but he revealed enough talent despite his shy posture and his fear of the microphone that Phillips wanted to try again. The record company boss called in a studio band, and Presley

recorded a version of Arthur Crudup's "That's All Right (Mama)." Phillips considered it so good that he took it to a Memphis disc jockey to play on his show. WHBQ's Dewey Philip played the song as requested, and the public got its first taste of Presley's blues-tinged-with-country voice.

WHBQ's telephone lines lit up with callers wanting to know the name of the artist. In response, Presley's demo was played fourteen times that day. Within weeks, the recording was a smash hit in the Memphis area.

WDIA refused to play it and subsequent recordings by Presley for two more years because the station's programming director did not think blacks would like listening to a white man's version of the blues. But it didn't matter. Elvis Presley was the talk of Memphis and the Mid-South. The rest of the listening world had not yet experienced the phenomenon, but people like Mayfield who relied upon the Memphis stations that reached small North Mississippi towns like Ecru certainly had. They were captivated by Presley's sound to the point that they did not want to hear much of anything else. They wanted all Elvis, all the time.

Mayfield liked the way Presley's sound made him want to move. Feet, hands, it did not matter—he just wanted to move. He could not dance around the house all day, though, not with his mother there. But he could pay homage to Presley as he had done years before with Joe Louis and George Washington Carver—in sculpture.

King of Rock and Roll

He did not have the materials Ole Miss students used in sculpting class, so he made up a batch of papier-mâché, using water, starch, and glue to form a liquid adhesive. Upon dipping outdated newspapers into the mixture, he had construction material for making a bust of Elvis Presley.

Mayfield had seen pictures of the singer in the

Commercial Appeal, so he had a template for Presley's slicked-back black hair, thick, dark sideburns, high cheekbones, and chiseled facial features. As with the busts of Louis and Carver, he placed Presley's image on the front porch. Soon, motorists and foot travelers along Mississippi Highway 15 were taking notice and stopping for a closer look.

"That's Elvis," they said. "Hello, Elvis."

By 1955, Presley's national fame was advancing as fast as the calendar pages turned. His sound was addictive and his gyrating moves on stage electrifying. The combination was unlike anything people had experienced before. He began the year as a third or fourth billing on show cards but was a headliner by early spring. By late spring, his shows were sold out to hysterical fans. By summer, Presley was topping the national charts. The regional press, wanting to get close to the singer to better understand his overnight fame, leaped upon any story it could find to keep readers coming back for more.

When word of Mayfield's Elvis sculpture spread, newspaper reporters from Tennessee to Alabama came to write stories about the black man in Ecru who had canonized the overnight star with a bust on his front porch. Feature stories about Mayfield's time at Ole Miss, his return home, and his papier-mâché Elvis ran in both the morning and afternoon papers in Memphis and in the *Tupelo Daily Journal* and the *Birmingham News.*

The publicity led to his first public art exhibit after

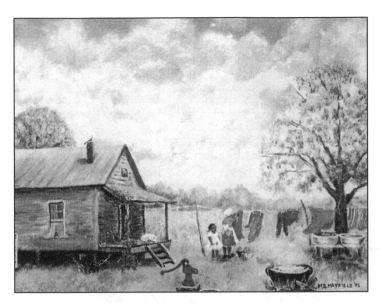

Wash Day #2

an architect in nearby Starkville, Mississippi, read about Mayfield and offered to arrange a show. Mayfield's exhibit was held in January 1955 at the Community Youth Center in Starkville. He had sold paintings before, but never so many at once—almost half his works. That meant Mayfield was able to supplement his mother's welfare check in supporting the household. And it meant he was inspired to apply all his free time to painting.

Mayfield no longer missed Ole Miss, though he cherished his time there as a life-changing experience. He followed the news about the rise of Coach Johnny Vaught's Rebels to the top of the Southeastern Conference. With Confederate battle flags waving by the thousands in the

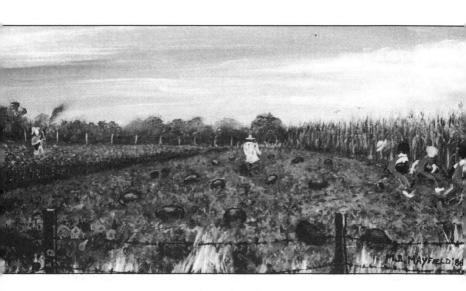

The Melon Thieves

stands and the sounds of "Dixie" in the air, Ole Miss emerged as a football powerhouse in 1954 and 1955, winning conference titles as Vaught's strategy of recruiting the best white Mississippi boys to play for the Rebels paid off.

But the item that garnered the most attention from Mayfield was the news in 1955 that Blind Jim Ivy had died. The funeral service, held at Oxford's Second Baptist Church, attracted an overflow crowd of whites and blacks. Ivy's death spurred a money-raising effort by Ole Miss students to endow a scholarship in the name of the university's unofficial mascot. Following the collection of more than a thousand dollars, the Blind Jim Scholarships were established to enable "Mississippi Negro youngsters to attend Negro institutions of higher learning." The irony, of course, did not seem like irony at all. The students' deed was celebrated by administrators for its thoughtfulness and kindness.

Inspired in 1955 by his regional press clippings and the paintings he had sold, Mayfield sought to further his education, applying to the Famous Artists School, a three-year correspondence program based in Westport, Connecticut, and spawned by America's amateur artist movement of the middle twentieth century. With more wealth and more free time in the period of economic growth after World War II, hundreds of thousands of citizens aspired to become artists. Most wanted to paint pictures like those they saw by Norman Rockwell on the

Hog Killing

cover of the *Saturday Evening Post.*

The Famous Artists School had been founded in 1948 by Albert Dorne. Advertisements in newspapers throughout the country promoted the school's twelve famous artist "instructors" who had created the twenty-four-course lesson program. Among those said to have developed the school's five thousand instructional drawings and diagrams was Rockwell.

Theora Hamblett had enrolled in a correspondence course from the school. So had thousands of other aspiring artists throughout America. The school's advisory artists

were earning more than fifty thousand dollars a year each, an extraordinary sum at the time. The total cost for the program was around three hundred dollars. Mayfield, however, won a tuition scholarship. He received drawing assignments by mail and sent his work back for evaluation, which was returned by mail with more assignments. He worked for three years on the assignments and received a completion certificate that he framed on a wall in the house.

In 1957, popular newspaperman Eldon Roark—who wrote the "Strolling" column for the *Memphis Press-Scimitar*, the city's afternoon daily—did a feature story on Mayfield that included photos of the artist's work, including his Elvis bust. The story led to more sales. Even though prices rarely exceeded twenty-five dollars, Mayfield was inspired. The Ole Miss experience initiated by Purser had helped him become a practicing professional artist, even if he earned only a very modest living at it. His mother's welfare checks gave them enough to get by, and he had never lived differently anyway. Mayfield was happy doing what he loved.

In late 1957, his mother's health deteriorated again, due to a heart condition. She died in her sleep in May 1958. Mayfield was despondent, having spent his entire life with the exception of the three years in Oxford with her.

A sister living in Racine, Wisconsin, invited him to visit after their mother's death. He went for two months

before returning home and attempting to revive his creativity. Alone in the house for five years, Mayfield produced little, working various part-time jobs in the area to pay bills. The uneasiness he had once felt was back, and he knew he needed a change. Mayfield yielded to his wanderlust, moving to Racine in 1962.

The total black population of Wisconsin had been less than three thousand after the turn of the twentieth century. But during World War II, blacks from rural areas in Mississippi, Arkansas, and Tennessee moved to the state in large numbers in search of factory jobs that paid better than what they could find at home. By the early 1960s, Wisconsin's black population was more than seventy-five thousand, the vast majority transplanted Southerners. The segregated society was no better than what they had experienced back home. The economics, however, were considerably improved.

Mayfield missed the South, but he found work doing janitorial and other odd jobs, so he remained, toughing it out while putting his passion aside. The joy was gone. He discovered he could no longer paint for the simple sake of doing so.

THE NEW ERA

Change is sometimes so elusive that the trends of the day seem like they might last forever. Then it comes with the unexpected force of a lightning bolt. *Crack*. And just like that, nothing is as it was. And so went the story of Oxford and Ole Miss in 1962, when the frailties and strengths of man left indelible marks upon the landscape.

The first of the two nationally publicized, history-making events that year began in the summer, shortly after William Faulkner checked into a sanatorium for treatment for alcohol abuse. The Oxford author had been an off-and-on visitor to Wright's Sanatorium in Byhalia, Mississippi, since the facility opened in 1949 to care for patients with drug or alcohol addiction or minor nervous disorders. Housed in a one-time residence in an obscure

rural area and run by a sympathetic staff that provided personal service in an intimate setting, the sanatorium was the choice of many well-to-do patients from the Mid-South. Faulkner visited when he fell prey to his notorious drinking binges and wanted to stop. His first trip came after spending days in a near-comatose state from alcohol overindulgence while writing *A Fable*. The visit in the summer of 1962 was his last. Faulkner suffered a heart attack the day after his arrival and died at the age of sixty-two.

He was buried in Oxford on a sweltering July day. Citizens crowded the streets and sidewalks of the town square and watched with somber faces as the cars in the burial procession wound their way toward the city cemetery. Young Virginia novelist William Styron covered the funeral for *Life* magazine. His story appeared in a four-page spread with accompanying photographs. Styron noted that Oxford businesses had closed out of respect for Faulkner and that the literary great was laid to rest "on a gentle slope, between two oak trees." In front-page stories, President John F. Kennedy was quoted as saying, "Since Henry James, no writer has left behind such a vast and enduring monument to the strength of American literature."

At the time of his death, Faulkner's books had sold more than ten million copies. His worldwide reputation gave Oxford the distinction of being something beyond a university town.

Attention to Faulkner's passing was short-lived, though, as the national media found a much bigger story in Oxford, and at Ole Miss in particular, in the early days of the fall of 1962.

Mississippi-born James Meredith was attending the all-black, state-supported Jackson State College in 1961 when he applied on two different occasions for enrollment at Ole Miss. Both times, he was denied. Armed with a full understanding of his rights and the support of the NAACP, Meredith appealed the decisions to a federal district court, arguing that he had been denied solely because of the color of his skin. The federal court initially ruled against Meredith, but that decision was overturned on appeal, meaning that Ole Miss was about to enroll its first black student.

Mississippi governor Ross Barnett did not want the integration at the state's flagship university to happen while he was in office. Appealing to whites through political grandstanding, and using the powers of his office in every way possible, Barnett tried to keep Meredith out of Ole Miss.

"In order to preserve the truth, and in order to maintain and perpetuate the dignity and tranquility of the brave and tall State of Mississippi, under such proclamation do [I] hereby, now and finally, deny you admission to the University of Mississippi," Barnett publicly proclaimed.

His well-publicized opposition worked white supremacists into a frenzy. Ku Klux Klan chapters from as

far away as Louisiana joined the cause, expressing outrage at the possibility that a black man would gain entrance to the university against the governor's will.

Though Barnett suspected he would have no choice but to abide by the federal ruling, he wanted to put on a show of opposition to earn praise from white constituents. He tried to broker a deal with the White House to let him make a statement on campus in front of the Lyceum door while federal marshals marched Meredith up the steps for admission. Barnett's plan was to make his objection before the marshals drew their weapons and ushered Meredith into the university. But the government considered the plan dangerous.

Early that fall, Barnett worked forty thousand Ole Miss football fans at a game against Kentucky in Jackson into a lather with a fiery halftime speech about his love for Mississippi's traditions and customs. The next day, federal officials enacted orders from President Kennedy, quietly ushering Meredith onto campus and enrolling him.

National journalists had been in Oxford for days covering the story. Among them was Albin Krebs, the former Ole Miss student newspaper editor. After his wife and infant child died, Krebs had graduated from Columbia University's School of Journalism and received a Pulitzer fellowship to study and travel in Europe. Back in the United States, he worked for United Press International and *Time* magazine before taking a job at *Newsweek*, which sent him to his old stomping grounds

when the federal court ruled Meredith should be admitted to Ole Miss. What transpired in the dark days when Krebs returned to campus surprised even the battle-experienced journalist, who knew to expect the worst.

Word of Meredith's enrollment spread with the speed of a wildfire. Members of white extremist groups looking for conflict converged on Oxford to make a statement. The vast majority of university students and town residents stuck to their dormitory rooms and homes, seeking to avoid what was becoming a national crisis.

Federal troops sent to ensure Meredith's safety were attacked by the agitators, who looked, as one onlooker recalled, like vermin running from an overturned log in the forest. Most had never been to college and had no connection to Ole Miss whatsoever. Their only common threads were hatred and the desire to continue segregation.

Federal officials sent to manage Meredith's enrollment were holed up in the university's administrative building when the onslaught began. One of them called Washington from a pay phone to inform Attorney General Robert Kennedy of the attack.

"It's getting like the Alamo," the official said.

"Well," Kennedy replied, "we know what happened to those guys."

The crowd members hurled brickbats, sticks, and homemade firebombs at troops deployed in full military gear. The troops responded with teargas. Shots rang out as

the sun set. Military helicopters whirred overhead. Crowds of outsiders swarmed the town hall, declaring war on the military, who ordered them to leave.

Ole Miss did not fall like the Alamo, however. By daybreak, the riot was under control. Two people were dead, more than sixty marshals were injured, and the reputations of Oxford and Ole Miss were damaged. The news from North Mississippi trumped all other national stories.

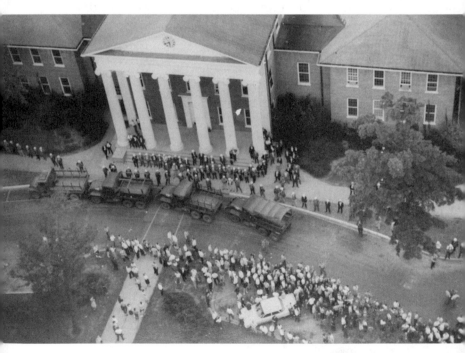

The scene at the Lyceum during the rioting surrounding James Meredith's admission to Ole Miss

One of the dead was French journalist Paul Guihard, who was found ten minutes after the rioting began with a bullet wound in the back of his head from an apparent point-blank firing. The day before, Guihard had filed a story—his last—with his French press agency. "People are not at all aware of the enormity of their gesture, of its repercussions and of the interest it is creating all over the world," he wrote.

The edition of *Newsweek* that ran on October 15, two weeks after the riot, included Krebs's reporting. The cover photograph showed a military man donning a teargas mask and a metal combat helmet in front of the white-columned Lyceum. The headline read, "The Sound and the Fury, Oxford, Mississippi."

Even Faulkner never wrote such a sordid tale.

M. B. Mayfield watched network reports of the riots at his apartment in Wisconsin. He could hardly believe the place he so loved was embroiled in such a hateful controversy. Until that time, he had liked to tell acquaintances his story of learning at Ole Miss. But after the Meredith-inspired riots, he stopped talking about how he had once listened secretly from a broom closet at the university. Meredith, he decided, had paid the heavy price, actually gaining admission despite the fervent efforts of white politicians and extremists. His own story, which had developed quietly and humbly more than a decade earlier, no longer seemed important.

After several years in Racine, Mayfield had begun

painting again, using the work as therapy for the wound he felt being away from home. He did a pencil drawing of his Ecru homeplace, showing the *L*-shaped frame house in the background, fronted by two chickens pecking in the yard, the well waiting to be primed, and an oak tree. He was also earning more than ever before. He saved everything he could so he would not end up like his mother, without money to fall back on later in life.

While in Memphis in 1967 to visit his twin brother, L. D., Mayfield heard of a janitorial opening at the Brooks Memorial Art Gallery, where Purser had taken him almost two decades earlier. The union seemed natural. He missed the South and thought he could perhaps find the kind

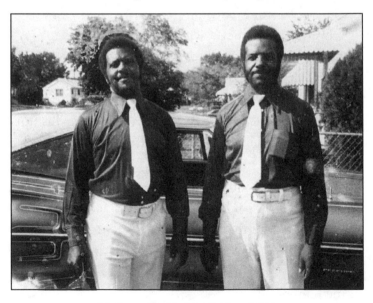

M. B. and L. D. Mayfield in 1974

of nurturing at Brooks that he had known at Ole Miss. Mayfield applied.

For almost a week, he prayed to God that he would get the job, firm in the conviction that Memphis should be his new home. Blacks had made considerable progress there since the first time he had visited with Purser. By 1967, the city's voting-age population and turnout levels among minorities exceeded those of whites. Memphis blacks had a voice and political clout. That same year, voters approved a newly structured city government that would ensure that at least three blacks would hold seats on the municipal council. Progress in the fight for civil rights in the city was undeniable, and Mayfield wanted to be part of it. He also wanted to move closer to his two brothers and to get back into an arts environment.

On his sixth day of prayer, the telephone rang at his brother's house. The Brooks Gallery wanted Mayfield to become its janitor.

He accepted the job and moved to Memphis the next week. The sign that had once restricted days when blacks could visit the gallery was no longer there. The staff members knew Mayfield was himself a practicing artist and welcomed him with the same embrace he had received at Ole Miss.

Being around the renowned works housed at Brooks inspired him to paint with renewed zeal. He was captivated by the paintings of Hobson Pittman, an influential instructor at the Pennsylvania Academy of Fine Arts in

Philadelphia who was recognized for the way he used stylistic and iconographic elements to explore themes of loneliness and memory. Pittman's art touched Mayfield in a way none had before. He recognized similarities between Pittman's style and his own and was inspired to delve deeper into his creative journey. Mayfield purchased new supplies and set up workspaces in his apartment and in the boiler room at Brooks. He developed works based on images he recalled from his youthful days in Ecru, including cotton picking, sorghum making, eating dinner on the grounds at church, and skinny-dipping in a swimming hole.

During Mayfield's second year back in the South, the civil-rights movement took a horrible turn. Memphis was desegregated in 1968, but employment and income disparities between whites and blacks were still glaring. A strike by city sanitation workers was long under way when Dr. Martin Luther King visited in a show of support for blacks seeking to end wage discrimination.

In 1955, King had been a prominent leader in the Alabama bus boycott. In 1963, he led a massive civil-rights march on Washington and delivered his famous "I Have a Dream" speech. In 1964, King was awarded the Nobel Peace Prize. In 1966, after James Meredith was wounded by gunfire during a one-man march from Memphis to Jackson, Mississippi, to encourage blacks to vote, King was among several black leaders who completed Meredith's journey. By the time he arrived in Memphis in April 1968, the thirty-nine-year-old King had survived

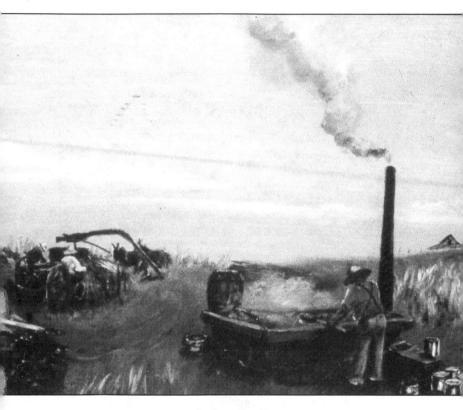

Cooking Sorghum

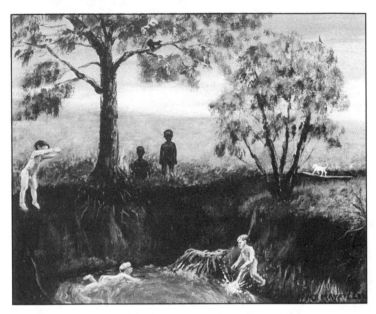

The Old Blue Hole

several attempts on his life and was still under threat.

On the night of April 3, more than three thousand people crowded into Mason Temple, a 1940s structure that served as the national headquarters of the Church of God in Christ, a large black Pentecostal denomination. They had come to hear a speech by one of King's associates, the Reverend Ralph Abernathy. But Abernathy told King that those gathered wanted to hear from him, so King agreed to address the crowd. As he spoke, sweat gathered on his brow in the overheated room, and the packed audience began to hum like bees in a hive.

"Well," King said, "I don't know what will happen now.

We've got some difficult days ahead. But it doesn't matter with me now. Because I've been to the mountaintop. And I don't mind. Like anybody, I would like to live a long life. Longevity has its place. But I'm not concerned about that now. I just want to do God's will.

"And He's allowed me to go up to the mountain.

"And I've looked over.

"And I've seen the promised land. I may not get there with you. But I want you to know tonight, that we, as a people will get to the promised land."

The next evening, April 4, 1968, King stood on the balcony of the Lorraine Motel after spending the day going over details of the planned march in support of the striking sanitation workers. He was outside Room 306, standing by aides. The sun was setting, but enough light remained for a gunman with a high-powered rifle to identify his target. A single shot rang out. King flailed in the air. When his body came to rest on the ground, aides saw that his jaw was dislodged.

A white man, convicted felon James Earl Ray, fled the scene, dropping a .30-06 rifle. He hid in an adjacent rooming house but was later caught and convicted of King's murder.

The severely wounded King was taken to a Memphis hospital. He died an hour later, setting off rioting in Memphis and other cities across America. A dawn-to-dusk curfew was imposed in Memphis. President Lyndon Johnson, sworn into office on November 22, 1963, after John F. Kennedy's

assassination in Dallas, sent federal troops to restore order while pleading for Americans to end the violence.

M. B. Mayfield was enjoying an evening dinner following a day's work at the Brooks Gallery when he heard the news. Like most Americans, Mayfield was overwhelmed by his emotions. So much progress had been made. Then *bang*, just like that, King was gone. He wondered if blacks would ever be left alone.

With the Brooks Gallery closed, and with nowhere to go amid the chaos in Memphis, Mayfield spent his idle time painting a portrait of King, revealing the slain civil-rights leader in a pose with clasped hands and focused eyes.

In Florida, Stuart Purser wrestled with his own emotions when he learned of King's death. For more than four decades, he had watched whites and blacks clash in the South. No matter where he had lived—whether Louisiana, Tennessee, or Mississippi—the conflict he had first witnessed between Applehead and the Lakite boy had played itself out time and time again. The names, places, and methods changed, but the issue was always the same—whites using anything in their power to keep blacks from equal opportunity.

In his artwork, Purser was still concentrating on the struggle of the Southern black man. But he was no longer serving as Art Department chairman. He found leading the department more of a challenge than he wanted. Florida State University, a women's college until becoming

I Have a Dream, Mayfield's portrait of Dr. Martin Luther King

coeducational in 1947, had a stronger art program than the University of Florida, and Purser felt the battle to build a first-rate department was too difficult. He stepped down as chairman in 1957 and taught classes in advanced painting and drawing while focusing on his own work.

He never lost the passion for promoting folk art that had led him years before to knock on M. B. Mayfield's door. Driving on Northwest Seventh Avenue in Gainesville one August afternoon in 1968, Purser came to a stop in front of a small yellow house when he noticed a figure displayed

on the edge of the front porch. A large wooden head carved from a heavy oak log was mounted on a tripod, and Purser could not take his eyes off it. He got out of the car and approached the house, where he encountered a small-framed elderly man of about 130 pounds who was seated in a purple rocking chair while clutching a corncob pipe between his teeth.

"Jesse J. Aaron is the name, and I am a sculptor," the man said.

Purser told the man he liked the sculpture and wanted to purchase it. The eighty-one-year-old Aaron said that the carving was his first and that his neighbors had been teasing him about it. Purser noted two signs the man had apparently just posted on the front of his house. One read, "Jesse J. Aaron, Sculptor." The other read, "Jesse J. Aaron Museum."

Purser laughed to himself. It seemed Aaron was not too bothered by his neighbors' remarks. He offered Aaron what he thought was a fair price for the work, hoping to take it home with him. Aaron accepted but professed discomfort with the transaction, saying the carving was not worth as much as Purser paid.

"If you come back next week," Aaron said, "I'll have some better ones."

Aaron explained that he had ordered a load of wood and was planning to carve all weekend. Purser was all too familiar with the well-intentioned but overzealous promises of first-time and would-be artists. But when Aaron looked

him in the eye, he made the decision to return, suspecting by the man's conviction that he was completely serious.

Born in Lake City, Florida, in 1887 to one parent who was black and another who was Seminole Indian, Aaron was one of eleven children in an impoverished household. He quit school at an early age and for many years did manual jobs including cabinetry, farm work, and cooking. Later in life, Aaron moved to Gainesville, where he owned and operated a small nursery. He had sold it earlier in 1968 to pay for his wife's cataract surgery.

With no means of income, Aaron said he had prayed to God for guidance. One July morning, God had spoken to him and said, "Carve wood." Aaron worked for two days until he finished his first piece, the one purchased by Purser.

By the time Purser returned as promised one week later, Aaron had seven new pieces and a skeptical wife, who wondered out loud about her aging husband's new profession.

"This old man has been up at three o'clock every morning since you were here," she said, "pecking away at that wood, keeping not only me awake but all the neighbors as well."

Aaron offered Purser one of his new pieces as a gift, convinced the art professor had overpaid for the first sculpture. Purser declined, offering instead to help develop Aaron's budding career by getting the work deserved exposure. Aaron outlined to the art professor

two specific ways he could help. One, Purser could have a thousand business cards printed with Aaron's picture, name, profession, and address on them. Two, Purser could help him find a good chain saw for cutting the logs and blocks he worked with. Purser suggested Aaron might not yet need the business cards, since he so far had only one paying customer, and that if they took some time and shopped around, they could probably find an inexpensive used chain saw.

Aaron did not like either response, telling Purser, "There won't be any more sales if people don't know about my work," and that if they got the best saw now, "I will be using it for ten or twenty years."

Purser helped Aaron on both points.

Within a month, he approached the director of the University Gallery about sharing his personal exhibition space with Aaron. The director agreed, albeit reluctantly.

Newly discovered sculptor Jesse Aaron was immediately well received by the university community.

Over the course of several years, his work—figures he claimed he could see in the wood, including images of raccoons and deer and human faces he interpreted in the funkiest of ways—gained renown among serious critics. Aaron worked hard to not let them down. Saying he was inspired by God to create, the artist labored most every waking hour seven days a week to produce as many pieces as he possibly could. His story was adored by the national media. Feature articles appeared in the *Christian*

Science Monitor and *Weekly Reader* magazine. CBS News produced a segment on him.

The timing of his discovery could not have been better for Aaron, considering a nationwide movement was under way among academically trained artists who were taking up the cause of their self-taught brethren. Students from the University of Louisville were captivated by a large mechanized sculpture from castoff materials built by a retired brick mason named Henry Dorsey in his front yard in Brownsboro, Kentucky. Students and teachers from the University of Arizona were making monthly visits to the Sonoran Desert to buy figurative woodcarvings by Seri Indian artists. And the unique landscape drawings of a self-taught black artist from Chicago named Joseph Yoakum were being discovered by academicians and collectors on the West Coast. Aaron and his sculpting were quickly placed in the same category as the other great discoveries.

In Memphis, Mayfield was working in considerably greater obscurity, attributable perhaps to his work's not having extraordinary distinguishing characteristics like Theora Hamblett's dotted tree leaves, or to the fact that, by the time of the movement to discover primitive artists, he was long gone from academia, painting in the shadow of so many noted works at the Brooks Gallery. But he relished what recognition he did receive.

Museum employees were not allowed to exhibit their works, so Mayfield followed the encouragement of the Brooks director and displayed his art in the boiler room

and in offices and hallways the paying public never saw.

Later in his career, Mayfield was promoted to security guard, which gave him more time to talk about his favorite subject with museum customers and employees. He continued painting in his spare time, developing the largest collection he ever had at one time.

To honor his work, museum management allowed him to exhibit in the employee lounge, an event that opened with a staff reception featuring food, drinks, and music. Museum patrons who heard about the event showed up even though it was intended for staff only. Mayfield's entire display sold out. He saved the money, as he did much of his salary, in the hope of one day buying a house.

In Oxford, Hamblett's painting career flourished into the 1970s. She continued living alone in her small apartment and renting out the home's other units. A small hand-painted wooden sign on her front porch read, "Theora Hamblett Paintings." Her long, graying hair pulled back in a bun, dressed in pastel, below-the-knee, broad-collared dresses like those she had worn years earlier as a schoolteacher, Hamblett rarely appeared at social gatherings, spending most of her time painting. Her canvases ranged from childhood memories to Southern landscapes to religious and visionary works. They sold briskly. When she died in 1977, she left her artwork to the University of Mississippi museums.

Mayfield was in his tenth year in Memphis in 1978

when he received a long-distance call from Stuart Purser. Retired from the University of Florida for more than a year, Purser was still living in Gainesville. Wanting to reconnect with Mayfield, he invited him for a visit. They had not spoken in years, so Mayfield was delighted. He often thought of Stuart and Mary, recalling Sunday dinners and unexpected trips. He agreed to travel to Florida on Labor Day weekend. He would take the bus from Memphis, since he wanted to see the scenery along the way. And then he would fly home, though he had never been on an airplane and feared the mere thought.

For two days, Mayfield visited with Stuart and Mary, reliving moments from their past, catching up on family members, and talking about art. Purser showed Mayfield the cabin outside Gainesville he and Mary used for a studio and drove him to Jesse Aaron's house to meet the sculptor.

On the third day, the Pursers drove their guest to the Gainesville airport. As Mayfield waited to board the plane to Memphis, his legs trembled and his hands shook so much he could barely hold his ticket. Prepared for Mayfield's distress, Mary slipped a paper into his hand. It was inscribed with scripture from the Bible. He read it while waiting to board.

"For I am persuaded that neither height, nor depth shall be able to separate us from the love of God."

Calmed by the words, Mayfield enjoyed the flight. In fact, he told of the experience for years to come.

Back in Memphis, he reflected on his conversations with Purser in Florida. He realized his friend had helped him gain the courage to do what he dreamed.

Mayfield subsequently turned in his resignation notice at the Brooks Gallery, announcing to the director and staff that he was going home to become a full-time artist. His last day of work was September 30, 1979. The staff feted his departure with a reception and gifts.

Using his savings, Mayfield bought an old house in Pontotoc, Mississippi, and arranged to have it moved to Ecru. He and his brother were working on the lot where he planned to locate the house the day the structure came rolling along the road toward them on the bed of a big truck. Mayfield reached both hands to the sky and shouted in joy.

"I came home, and my home came to see me," he said.

Mayfield's new home in Ecru was anchored on family land next to his sister's house. He lived alone, but he and his sister gardened together, sometimes shared meals, and regularly visited in their adjoining yards. He still felt anxiety in social situations, which he attributed to severe claustrophobia resulting from his birth in a storm shelter. The anxiety often pushed him right to the edge of panic. He still battled shyness as well. But Mayfield was a different man living in Ecru as an adult from what he had been in his younger days, when leaving the safe confines of home had taken everything he had.

Friends from nearby Pontotoc visited frequently, and unexpected guests stopped by to inquire about his art or to buy pieces. When admiring patrons knocked on his door, Mayfield was usually so humbled that he had trouble asking the prices friends said he deserved. The fact that someone valued his work meant more to him than the money. Over the years, he sold more than two hundred works for as little as $1 but rarely more than $150.

"I almost give them away," he used to say.

Located about a mile north of downtown Ecru on Mississippi Highway 15, Mayfield's white frame house sat on a slightly elevated lot at the end of a curved gravel drive. Clumps of cactus two or three feet tall welcomed visitors at the driveway's entrance. Trees surrounded the house, protecting it from the searing summertime sun.

Inside, Mayfield's art decorated the walls. The flooring was dark, mostly covered in tar. Miscellaneous objects ranging from press clippings to gifts from friends remained in the first resting spots they found, often on top of an upright piano in the living room. A homemade easel fashioned from a wobbly-legged secondhand television cart sat in the middle of the kitchen floor. Scattered paints and brushes purchased from a mail-order supply house lay about the paneled room, where a row of appliances—water heater, washing machine, dryer, and stove—lined one wall.

The place was simple enough that Mayfield sometimes apologized to friends and visitors for its condition, but

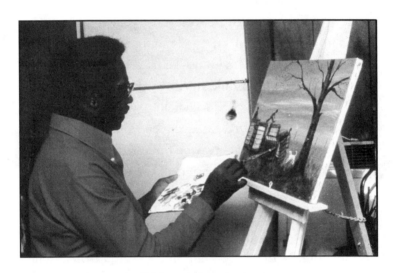

Mayfield painting in his kitchen

splendid enough that he often thought to himself in quiet moments how fortunate it was that his wandering spirit had found such a comfortable resting place. Satisfied with the roads he had traveled, Mayfield dreamed only of memories, bringing them back to life through his art. He was home to stay.

> I'm back in the dust of Ecru
> Been up North too long—
> Back to the fields of cotton—
> Back to the Mocking Bird's song.
>
> Back to the dust of Ecru
> And the old mule and plow—
> Back to the red hills and hollows—
> Back to the good milk cow.
>
> I'm glad to be back in the dust
> Where sweet-smelling flowers grow—
> Back in the dust of Ecru—
> Back where the roosters crow.
>
> Back to the old swimming hole—
> That once gave so much joy—
> "Take the boy from the country,
> But you can't take country from the boy."

> *M. B. Mayfield*

BACK TO OLE MISS

Time has a way of healing wounds, particularly when constant nurture is factored in. At Ole Miss, that combination made all the difference. The university evolved from its closed-door past into an inclusive, more sensitive institution by the late 1980s, using historical lessons as a guide toward a progressive future.

The transformation did not occur quickly or easily, of course. Qualified black applicants were admitted after James Meredith paved the way. By 1969, the university had a hundred black students. The Black Student Union was established, and Black History Week became a sanctioned celebration. The annual Dixie Week continued

taught to have nothing to do with it."

The university administration compromised by ruling that only one member of the cheering squad would carry a Rebel flag. The controversy continued, however. At the commemorative celebration for the twentieth anniversary of James Meredith's admission, Meredith, the keynote speaker, said the university should abandon the flag and any other remaining Confederate imagery. As a result, the Ku Klux Klan held a rally on the town square in support of the flag. Most of the several hundred spectators watching the demonstration heckled the twenty-five hooded white supremacists.

The controversy lingered into the next year, when six hundred Ole Miss students marched with Rebel flags in hand to the front of Phi Beta Sigma house, the all-black fraternity in which John Hawkins held membership. Some of the students voiced racial slurs. Two days later, the university officially disassociated from the Rebel flag.

In the mid-1980s, new Ole Miss chancellor R. Gerald Turner launched an aggressive student recruitment program specifically targeting African-Americans. Minority enrollment soon doubled. While Ole Miss continued to battle racial controversies, the university had moved well beyond its painful past.

Despite living for many years just over thirty miles away, M. B. Mayfield rarely returned to Ole Miss. But the university's racial maturity happened to coincide with his increased promotion of his work, resulting in the perfect

in the 1970s, but the overt embracing of the Confederacy disappeared.

Alumni, students, and fans clung more tightly than ever, though, to the Confederate battle flag. At football games, Ole Miss male cheerleaders ran onto the field carrying large flags. In the stands, fans waved thousands of mini flags mounted on sticks. The university band played a stirring rendition of "Dixie" whenever the team ran onto the field or scored a touchdown.

Ole Miss signed its first black football player in 1972. Gentle Ben Williams became an All-American defensive lineman and one of the most popular students on campus. To boost sagging attendance at Rebel basketball games, the university arranged for Williams to wrestle a bear at halftime. In 1975, students voted him the university's Colonel Rebel, among the highest of campus honors.

Racial controversy did not disappear, however. The student body elected John Hawkins as the school's first black cheerleader in 1982. Ole Miss had just over seven hundred black students, and Hawkins received more than twelve hundred votes. But Hawkins refused to carry the Rebel flag. Newspaper headlines throughout the state and vocal cries from traditionalists took issue with the perceived disloyalty. Hawkins, however, did not back down.

"I am an Ole Miss cheerleader," he said, "[which] makes me representative of the whole student body— blacks and whites—but I am a black man and the same way whites have been taught to wave the flag I have been

homecoming opportunity in 1986.

The timing was good for Mayfield. He was struggling to pay household bills in Ecru. Since he had used most of his savings to buy his house, and since sales of his paintings were slow, he had to do various part-time jobs for grocery money. He cleaned buildings and worked in a nursing home and in the town maintenance department—just about anywhere he could find extra income. Just as Mayfield's existence reached a state he described as "disgusting," Pontotoc County resident Lamar Wilder offered to help gain him more exposure by talking with the university about hosting an exhibit.

Ole Miss housed the internationally recognized Center for the Study of Southern Culture. The center, Wilder assumed, would be interested in the work of an artist who once learned secretly from the Art Department's broom closet. Though the center's director, Dr. William "Bill" Ferris, was unfamiliar with the story of M. B. Mayfield and Ole Miss, he was not at all surprised when told about the unique arrangement between the artist and Stuart Purser. Ferris knew Purser from their previous discussions on black folk art, particularly Jesse Aaron's woodcarvings, so Purser's mentoring of Mayfield made perfect sense. Ferris scheduled to meet with Mayfield at the first available opportunity.

Samples of his work, photographs from different stages in his career, and a professional résumé in hand, Mayfield went to Ole Miss to tell Ferris his story, from

Purser and Faulkner to the Brooks Gallery to his move back home. Ferris was struck by Mayfield's unassuming, almost apologetic manner and his self-effacing dialogue. Whenever Mayfield revealed to Ferris another painting, he could not help adding the just-in-case words, "It's not one of my better ones." When Ferris commented on the importance of Mayfield's work, noting how it told the too-infrequently captured story of the rural segregated South, Mayfield was so moved by the compliment that he stammered in response.

Charged with the missions of investigating, documenting, interpreting, and teaching about the American South, Ferris immediately knew the Center for the Study of Southern Culture should and would embrace Mayfield and his work. He also understood the significance of Ole Miss's recognition of Mayfield and public acknowledgment of his story.

Mayfield concurred.

"It's time to come back," he said.

An exhibit of Mayfield's paintings was scheduled for the next year to coincide with the university's annual Faulkner & Yoknapatawpha Conference, one of its signature events, known by scholars throughout the world. Since he had sold or given away most of his previous works, Mayfield needed the year to create the twenty pieces for the full exhibit. He went immediately to work while also doing other commissioned pieces increasingly in demand as word of his art spread

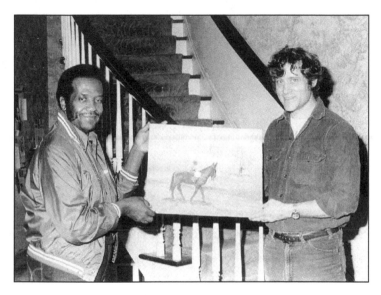

Mayfield with Dr. William "Bill" Ferris

throughout the Mid-South. Someone in Holly Springs, Mississippi, sent a five-hundred-dollar down payment for a work they wanted done. A bank in Tupelo, Mississippi, paid a thousand dollars for another. Never had Mayfield worked so hard or received so much in return.

The Faulkner conference had begun in the summer of 1974 as a way of helping scholars, students, and Faulkner fans better understand the writer and the world in which he lived. In 1986, the conference theme was "Faulkner and Race." It was to be a look at the relationship between the author and the segregated society he wrote about. Ferris learned from Mayfield and from his research that Faulkner had helped buy the artist's supplies and pay for his trip to Chicago, so linking the exhibit with the conference was natural.

Mayfield finished his quota of works for the show days before his deadline. He loaded them in Lamar Wilder's car and traveled with his friend to Ole Miss for setup just before the late-July opening. On the drive from Ecru, he remembered how he had felt the day in 1949 when he took the bus to Oxford, arriving on campus so nervous that he entered multiple wrong doors before finding Stuart Purser. He reflected on how far both he and the university had come.

University professors and students, art enthusiasts, and friends of the Center for the Study of Southern Culture attended the month-long exhibition. Stuart Purser did not, having passed away in Gainesville months

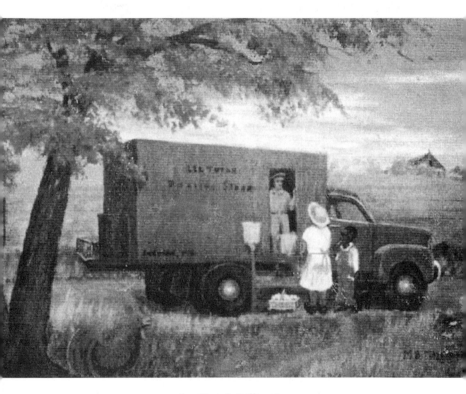

Lee Tutor's Rolling Store

earlier. Mary died not long afterward.

The Pursers' absence was the only blemish on Mayfield's homecoming. Everything else—from the publicity he received to the public's response to the exhibit to the university's acknowledgment of his work—was greater than any accolades he had previously experienced. For most of his life, he could not have officially attended Ole Miss even if he had been qualified. Now, he and his art were on public display and were being celebrated and studied. The university even distributed a press release acknowledging that Mayfield had in fact learned art on campus while he worked as a janitor.

"Nearly 40 years after he mopped floors and cleaned blackboards and studied art in a broom closet at The University of Mississippi," stated the release, run in dozens of papers statewide, "M. B. Mayfield returns to the campus with an exhibition of his paintings."

Mayfield's friendship with Ferris—a man respected nationally as the foremost authority on Southern culture—continued for a couple of years. Mayfield returned often to the Center for the Study of Southern Culture for visits and moral support. Ferris hosted a Sunday-afternoon blues show on Mississippi Public Radio. Mayfield was among Ferris's loyal listeners, and Ferris frequently mentioned the artist's name on the air and dedicated songs to him.

Ferris also helped Mayfield connect with other opportunities in the region. That effort, combined with publicity from the Ole Miss show, helped advance the artist's

career with more shows and more commissions. Mayfield kept track of special orders in a handwritten tablet, the notations accumulating at a pace that sometimes exceeded his organization. He exhibited paintings at the Mississippi Education Television office in Jackson for a month, won an award in a competition sponsored by the Center for Contemporary Arts in New Orleans, and exhibited at the Wheeler Gallery at the University of Massachusetts in Amherst.

With the exception of occasional portraits of personalities like Oprah Winfrey, Mayfield's paintings were interpretations of memories from growing up on the farm in Ecru. One, *The Caboose Man*, showed three black children waving to a man in a caboose as a train passed the homeplace. Sliced watermelons waited for the children under a tree. Another painting showed two black women peeling a bucket of apples on a front porch, while another showed Mayfield's pregnant mother fleeing for shelter as storm clouds raged overhead. Mayfield also developed his signature work, *Dr. Purser's Drawing Class*, a sort of self-portrait showing white Ole Miss students at their easels encircling an overalls-wearing black male model. His landscape paintings often included the image of a white dog reminiscent of one that had shown up at his family home one summer morning after an overnight rainstorm when he was a child. Mayfield tried to run the dog off, but she remained. He named her Whitey.

His works revealed so much candor that one critic

Mayfield's portrait of Oprah Winfrey

suggested observers might find them disquieting because of such imagery as black children with watermelons. Mayfield, though, followed his inspiration and the early advice of Purser, never abandoning his tell-it-as-it-was style. Longtime locals, of course, knew from experience that Mayfield's work only spoke truths.

Media coverage mounted over the years he was back home in Ecru. Mayfield was the subject of a German television documentary and dozens of newspaper feature stories.

The wife of Ecru mayor Tom Todd was one of Mayfield's most avid supporters. She bought many of his works, showing a preference for cotton field scenes. She pushed local officials to commission a painting for city hall. The post office got one, too, hanging it in the lobby. But the ultimate compliment came when the mayor and the board of aldermen staged a festival in Mayfield's honor, hanging a banner across Main Street and displaying his art in City Park.

On a sweltering July day, citizens crowded around a platform where Mayfield sat alongside the mayor and the town board. Children white and black played in the background. The banner proclaiming "Celebrate M. B. Mayfield Day in Ecru" was so large that the town's utility crew had to hang it. While the banner quietly rippled in the breeze, the mayor presented Mayfield a key to the city and a citation from the governor of Mississippi.

Clothed in a suit dampened with sweat, Mayfield

stood at the podium to accept the honor. His scant but telling words summed up just how far he had come in four decades.

"I feel happy," he said.

Such broad recognition in his hometown—where he was once ridiculed for being too shy, sensitive, and soft for survival in the segregated South—showed the significant healing that had occurred since his youthful days. The new rural South would not only accept but also embrace a black man who crawled backward. Mayfield basked in the affection, fully recognizing the progressive spirit.

In 1990, Mayfield changed churches, leaving the Baptist religion that had "saved" him as a youth during a summertime revival in 1934. Later in life, having had enough of conservative evangelism, he converted to Catholicism, joining a church with a mostly white congregation in nearby New Albany, Mississippi.

Firmly established regionally, Mayfield navigated the 1990s as a full-time artist, living off the proceeds from his work and his monthly retirement money.

"The world's full of two-bit jobs," he said. "I always wanted to stick with my artwork for a living anyhow— do nothing but paint for a living. With a Social Security check, that's how I survive. I like it that way. I can get something for this pot gut of mine and pay my bills. I'm happy."

Though Mayfield expanded his following with exhibits from Atlanta to San Antonio, his most significant

support was always close to home. When a gallery opened on the town square in Oxford, he was the featured subject of a show promoting primitive works. On the Ole Miss campus, the university museum housed several of his paintings, including a portrait of Dr. Martin Luther King. When a county historical museum opened in Pontotoc, Mayfield was chosen as the lone art exhibitor for the inaugural event. And often, he answered unsolicited knocks on his door from those seeking Ecru's best-known resident.

When Elmo Howell went looking for Mayfield to include him in a book he was writing, *Mississippi Back Roads*, he stopped at the Ecru post office to ask about the artist. Before giving Howell directions to the house on Mississippi Highway 15, the postmistress pointed to the painting on the wall she had purchased from Mayfield. Howell visited Mayfield for a couple of hours, during which he reviewed the works hanging from the walls and navigated the artist's oral history. He later wrote that Mayfield's "candor pleads no cause. He paints what he sees. His art is true and happy, like his life, and is much loved in the state."

As the years passed, painting became more challenging for Mayfield. Aging took a heavy toll after the dawn of the twenty-first century, unsteadying his hands and draining his creative energy. Memories from long ago were no longer so clear. Though he managed on his own for the most part, a niece increasingly looked in on him. Knowing his

days were numbered, with assistance from friends at the Pontotoc Historical Society, Mayfield published a booklet in 2004 that combined images of his art, examples of his poetry, and his life story. The publication was the culmination for Mayfield of a long-evolving journey.

In his early eighties, Mayfield covered his mouth when he spoke, trying to hide his missing front teeth. A bad leg limited his mobility. Tall grass and untamed shrubbery grew in the yard, and the interior of his house became slightly disorganized. He made apologies for the condition of his property but always kept the creaky screen door unlatched for guests including family, clergy and parishioners from his church, journalists, and friends.

Friends often took him food when he did not want to leave the house. Some were bothered by the incessant stream of roaches skittering about. Mayfield, though, was indifferent about the infestation. He was most comfortable at home, but less comfortable with change.

One frequesnt visitor was Galen Holley, the religion editor of the *Northeast Mississippi Daily Journal*. The two men formed a friendship. The artist told Holley the stories he could no longer express on canvas. The journalist kept notes and used them later in his weekly column.

Wrote Holley, "Mayfield is sitting at the piano, in a mist of dust and afternoon sunlight, playing. He's off-key and shrill. His fingers stretch painfully over the chords.

"A spectral image watches us from the wall, a

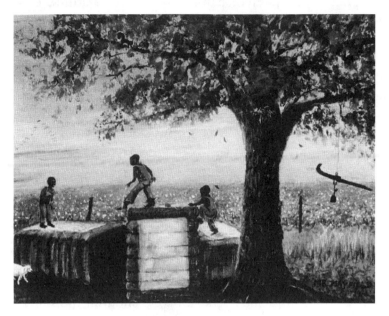

Cotton Bales

prim, black woman, her face inscrutable, primitively one-dimensional. The painting is smoky from years of absorbing the warmth of the wood stove. Against the threshold are more canvases in various stages of completion, Oprah Winfrey, Elvis, painted with large features, eye-popping bright colors.

"Mayfield is whispering. 'I remember that old preacher down the road here, when I was a boy. He didn't cotton to me going to a Catholic Church.' Mayfield's laughter is girlish, wheezing, unsettling.

"In his living room we are surrounded by images of scrawny, mischievous black boys. They're stealing melons, wrestling atop sacks of cotton, draping bony, arthritic poles over impossibly blue water. The inscrutable woman seems to be saying something from the wall, something about work and having too little time.

"Mayfield is mumbling, a memory about watching the painting class from inside the broom closet at Ole Miss. Then he remembers someone shouting poison at him from a passing car. He remembers standing there, beside the highway, putting the old barn through the filter of his mind and onto the virginal canvas.

" 'Father Don came out to see me Wednesday,' Mayfield says. 'Sat with me a spell, brought me Communion.'

"The floor is mostly tar, soft under foot, trapping all manner of filth. Roaches skitter in flashes over pulverized crackers rough like gravel. The TV tray Mayfield has painted, with gilded edges, child-like, in his endless spare

time, wobbles perilously. A frilly paper bell teeters in the breeze of a corner fan.

"Mayfield waves his hands dismissively, his eyes laughing behind his dark glasses, the artist's trademark. He shows me a photograph of one of his more popular paintings.

" '*There Goes Faulkner*,' Mayfield says. 'That's what I called it.' The late author rides in a green, military Jeep, snarling, his teeth clenching a cob pipe.

" 'He used to take along a little black boy to bait his hook and pour his whiskey,' Mayfield says. He says his teacher once told him that Faulkner liked his paintings.

" 'People saw him coming in that old Jeep and they'd say, "There goes Faulkner and that boy, gone fishing," ' Mayfield says. 'Faulkner was such a handsome man.'

"Mayfield tells me McCoy's will deliver his groceries if he makes a list, and he needs shoes, sandals, Velcro, he insists, for his swollen feet, but his years haven't squelched his vanity. 'They won't look too ugly, will they?' he asks.

"The room is filled with absurd objects, wire hangers twisted into a cross with Christmas tinsel around the edges, a coaster molded from yard clay, a hollow, plastic candy cane.

"I ask him, 'When did you paint the baptisms at the pond and who is that woman on the wall?'

"He says, 'In my mind, the sun always shone on days like that, couldn't be any other way.' After a minute, he adds, 'The people were always smiling, even when they

weren't. Better to think of it that way.' He struggles to stand, to replace the piano bench.

"He says, 'The blue water is the mystery, the great mystery of God. The white robes are purity, like a child.' He tilts up his dark glasses, rubbing the bridge of his nose.

" 'The woman is my grandmother.'

"Outside I hear the threatening, insistent drone of bees, large and boorish against the screen. The house is ringed with tall grass, home to serpents and stinging insects that threaten the walkway. An eternity of silence passes with only the buzz, the poisonous, stinging click, the rapping of a loose shutter in the breeze.

" 'Don't mind all that in the yard,' Mayfield says. 'That boy will be around sometime this week to see to it.'

"A long time passes with only the buzz, the click, the rap. We watch the inscrutable faces. The dark, smoky sadness of the room closes in.

" 'Oh, he'll come,' Mayfield says. 'Don't fret about it. Sooner or later, he'll come.' "

When friends and family did not hear from Mayfield for several days in the early summer of 2005, his niece went to the house to check on him. The sun was shining. Birds chirped in the trees, and a warm breeze blew. She opened the front door and found Mayfield sitting upright in a chair, unresponsive. The artist was dead at the age of eighty-two.

Chapter 10

FIREFLIES

Progress is often slow when the deep divide of racial differences stands in the way. In the nine decades spanned by the lives of Stuart Purser and M. B. Mayfield, sweeping changes occurred in the attitudes and the legal system that had created such distance between whites and blacks. The battle lines were so deeply drawn in the South a century after the emancipation of black slaves from the control of white landowners that Mayfield and many other people never expected to see significant advancement against oppression in their lifetimes. Yet Southern poll taxes were eradicated. Schools were integrated. Ku Klux Klan membership dropped to a fraction of what it once was.

But old habits can be hard to break. In Louisiana, for instance, the parish governed in the early twentieth century by the KKK under the leadership of Stuart Purser's

father became in the year after Mayfield's death the site of a national racial conflict. Less than two miles from Purser's childhood home of Good Pine, the town of Jena, Louisiana, erupted in 2006 in the same type of conflict that once grew between Applehead and Tom Girley, the boy who taunted him to the point of violence back in the mid-1920s.

Among Jena High School's enrollment of more than five hundred students, 85 percent were white and 10 percent black. Tension between whites and blacks flared at the school on the first day of September 2006 when three hangman's nooses were found in a tree in the school courtyard after a black student tried to sit in a spot normally occupied by white students. The three white students who hung the nooses claimed it was a tasteless prank. Blacks in the community felt differently, particularly when the school's principal suspended the white students, only to have the board of education overrule the decision and allow the students to continue in the county system under in-school suspension.

Over the following months, history repeated itself in Jena and LaSalle Parish. Fights between black and white students became commonplace. The school's main building fell victim to arson. One fight resulted in the arrest of six black students on aggrevated assault charges. They faced years in prison, even though the injuries inflicted on the white student they attacked after verbal procovation were only superficial.

A year later, the town of just three thousand residents was the site of an emotional protest attended by almost twenty thousand people demanding justice for the six black students, whom they argued were being unjustly charged as criminals. The march was one of America's largest in support of civil rights in decades.

But even as the small Louisiana community was embroiled in a controversy fueled by old wounds and the actions of individuals clinging to the unwritten rules of another era, the dismantling of the nation's racial barriers was still under way. Barack Obama, then the junior United States senator from Illinois, announced his candidacy for president in early 2007. The first African-American to run on a major party ticket, Obama claimed the Democratic nomination in August 2008, entering the general election against Republican candidate John McCain.

History could not have scripted a more fitting moment than when Ole Miss hosted the first presidential debate. Obama had been just fourteen months old when James Meredith integrated the university in one of America's ugliest civil-rights battles.

"I think what we have here is really a confluence of two lines of history, where you have a new Ole Miss, a postracial Ole Miss, and you have a postracial black candidate running for president," said David Sansing, professor emeritus of history at the university, just before the debate. "Nowhere in America could these two forces reinforce each other as they do here at Ole Miss."

On the evening of the debate, thousands of visitors poured onto the Ole Miss campus and Oxford's town square, where a large television screen was set up so viewers could get close to the history-making event. The Mississippi White Knights chapter of the Ku Klux Klan—which opposes mixed-race couples and solicits funds for white prisoners convicted of killing blacks during the civil-rights movement—planned to be on campus, suggesting the university might once again land in racial controversy. But the crowd—evenly divided among whites and blacks, Republicans and Democrats—peacefully watched and then quietly dispersed afterward. The university and the town thus faced potential racial conflict and emerged wrapped in harmony.

Such progress, of course, was built upon the prior actions of many. Some, like James Meredith, played their parts with barrier-destructing force. Others were quieter but had no less impact, lighting the path like fireflies flickering in the countryside on a hot summer night.

Perhaps that's why Purser and Mayfield shared something besides friendship and a drive to depict blacks in the rural South in the years before civil rights. Among the most prominent works of each is a painting of fireflies. Purser's *Chasing Fireflies*, done in 1945, shows men scaling hills in a moonlit sky, grasping for small emitted lights. Mayfield's *Fire Flys*, completed in 1989, shows a frame house reaching toward the many lights swarming overhead in the darkness.

Applehead was a firefly. So were Stuart Purser, his father and mother, and his wife, Mary. And M. B. Mayfield was a firefly. So were William Faulkner, Theora Hamblett, Albin Krebs, and many others who had a meaningful impact on the lives of many.

Seemingly, they should not have had much in common. One was barely known outside family and friends, while one won a Nobel Prize. One received just acclaim as an artist, while another never received nearly enough. But each in the end was a firefly, relying upon associations with others to create from intermittent illumination a harmonious lifting light.

Consider that Mayfield and Krebs never met, even though they were at Ole Miss at the same time, working just steps away from each other while battling for the same cause, albeit in different ways.

Krebs became a reporter for the *New York Times* in the late 1960s after his stint at *Newsweek*. He served on the newspaper's obituary staff from 1969 until his retirement in 1989. His obituary subjects included Mississippi writer Eudora Welty, food critic James Beard, Lyndon Johnson, and Truman Capote. Among his closest friends was Tennessee Williams, the Mississippi-born playwright who penned *A Streetcar Named Desire*. After losing his wife and infant son during childbirth in the 1950s, Krebs remained single. On most holidays, he volunteered for work at the *New York Times* so staff members with families could be at home. Late in his career, Krebs made peace with his alma

mater, donating money to the Journalism Department at Ole Miss. The Albin Krebs Journalism Scholarship was established in 1989. After retirement, Krebs moved to Key West, Florida, living among friends as the freest of spirits. He always commanded an audience for his stories of Ole Miss, Korea, and Tennessee Williams. Krebs shared a backyard pool with several neighbors. Wearing a tiny, rainbow-colored G-string bikini, a stud in his pierced left nipple, he floated in the pool most afternoons, sipping whiskey from a duct-taped thermos. Krebs was long gone from the days when being anything other than a conformist had yielded harsh penalties. Like Mayfield, the Pursers, Faulkner, and everyone else who had survived the great storm back in the day, he had learned to tell about it with the greatest of ease. He died of cancer in 2002 at the age of seventy-three.

William Faulkner passed away just months before James Meredith enrolled at Ole Miss. Though he did not live to see the full impact and recognition of his work throughout the world, Faulkner is now recognized as one of the most influential writers of the twentieth century and is one of the authors most studied by scholars. His name ranks high among America's all-time literary greats. Almost five decades after his death, his works still sell worldwide.

By the time Theora Hamblett died in 1977 at the age of eighty-two, she was firmly established as one of the most renowned primitive artists of the twentieth century. Her

unique rendering of trees became her trademark. Hopeful patrons often placed orders by knocking on her door and either choosing from the sparse selection on hand or joining a waiting list for future works. Hamblett's art was exhibited in Belgium, New York, Atlanta, Memphis, and Jackson and is currently on display in galleries all over the world. Her works are actively collected, typically selling for twenty thousand dollars or more. The University of Mississippi Museum maintains the largest public collection of Theora Hamblett paintings.

Mary Purser received a Master of Fine Arts degree from the University of Florida after her husband took a job there. She taught elementary school in the Gainesville area before becoming an associate professor at the university's College of Education in 1966. She retired in 1976 at the same time her husband did. She was also active in the Gainesville Art Association and her church. The couple's son, Robert "Bob" Purser, received a Master of Fine Arts degree from the University of Washington and a Ph.D. from the University of Oregon and became an art teacher at Bellevue Community College near Seattle. Bob talked with M. B. Mayfield several times over the years after his parents' deaths. The couple's daughter, Jean, married and became a high-school art teacher in Gainesville.

After Stuart Purser retired from the University of Florida in 1976, he rented with his wife an old barn ten miles outside Gainesville. They remodeled the loft into a studio for painting and writing. There, Purser wrote several

books, including *Jesse Aaron*, the story of the black folk artist he had discovered, and *Applehead*, which detailed his experiences growing up in Louisiana with a black best friend and a father in the Ku Klux Klan. Another book, *Catahoula Cur*, exposed the barbarity of the illegal but popular sport of dog fighting, which occurred secretly in the South much like meetings of the KKK. Purser continued painting, focusing his efforts on the struggle of the black man. He and Mary died within months of one another in 1986. The works of Purser and his wife and son may be seen at the website www.purserstudio.com.

M. B. Mayfield never achieved widespread notoriety and commercial success, but his work was appreciated by art enthusiasts and friends all over the world. Art was both his lifeblood and his passion, and Mayfield was always humbled when people paid to have his work. Though he never forgot his friendship with Stuart Purser and his days at Ole Miss, he didn't talk about them in much detail, suggesting that James Meredith deserved the credit for officially becoming the university's first black student. Ecru was the place where he grew comfortable being nothing more than himself. The town's movie theater was gone, and the summertime church revivals held no allure, but he had those memories. Mayfield told stories until the end, brushing them onto canvas, offering neither excuse nor apology, hoping people would see that a sometimes-difficult life was also a life well lived. At his death in 2005, very few paintings remained in his possession, since he

had either given away or sold most of the hundreds of works he completed in his lifetime.

But his stories, along with those of so many others, continue illuminating the dark nights.

Epilogue

Ole Miss was my first love. Anything colored in red and blue glistened on even the darkest days. Growing up in its shadows, the university was a playground in my youth. As a student, Ole Miss was my lifeblood, providing sustainability and motivation to explore. As a young adult, I remained in Oxford, buying a home that actually touched university property. For years, I determined the routes of my long morning or afternoon walks by which corner of the campus would serve as the turnaround point. I reserved my weekends for ball games and consumed all available cultural events.

But one day, I woke up and decided it was time to leave. Like conflict that develops with a close family member, I became frustrated by the university's obvious historical flaws. How could I so love a place with such an

insular past? So I left, moving hours away by car and miles away in spirit, trying to convince myself that Ole Miss really did not matter that much after all. Call it a trial separation with the intention of never going back.

For several years, I was content in the decision, buoyed by the experience of discovering life outside the Ole Miss universe. In the beginning, affirmation came from people who did not know the university through decades of experience as I did but relied instead upon stereotypes linked directly to history. I listened and asked questions myself. And when my oldest son began looking for a university to attend, I pushed him as far away from Ole Miss as I possibly could.

Eventually, though, a different tone began to emerge from those who had not previously known the university. They did not discuss the past, but rather the present and future. A new era was obviously afoot, which led me to ask questions of myself. Specifically, I wondered if the place that once seemed so wonderful was actually as I once thought, even if it did fight far too long to keep blacks from its classrooms and cling even longer to racist symbols like the Confederate battle flag.

This new Ole Miss they were talking about was promising enough to sway my oldest to enroll, despite my earlier fatherly advice. And it was promising enough to draw me back for a close reassessment. What I found surprised me. My love had not diminished because of time and distance but had in fact grown. I was better able to

recognize and understand that, like people, institutions are not perfect—far from it, in fact. The key element, then, is not past mistakes but lessons learned for the future.

Ole Miss certainly has had its share of learning opportunities. Beginning with the pre-civil-rights white supremacist era that coincided with M. B. Mayfield's arrival in 1949, continuing through James Meredith's enrollment in 1962, and even extending to the flaunting of the Rebel flag into the early 1980s, Ole Miss accrued more than three decades' worth of painful lessons. But the distance allowed me to see that the university wears its mistakes well, openly displaying its scars to show that even the deepest wounds can heal if treated properly.

In January 2009, I returned to campus for something other than attendance at a sporting event. At the age of forty-three, I was uncomfortable in my first steps back. But I had not walked more than a few hundred yards before I heard a familiar voice. University chancellor Dr. Robert Khayat had as much to do with my Ole Miss love affair as anyone, I suppose, dating back to a small but important act of kindness when I was in grade school and continuing through the years in myriad ways. It was fitting that he was the first person I encountered.

"This place has changed so much," he said that day. "It's not the same."

He of all people should know.

Dr. Khayat arrived at Ole Miss in 1956 on an athletic scholarship. He later played three years in the

NFL, returned to Ole Miss for law school, became a vice chancellor for university affairs, served for three years as president of the NCAA Foundation, and came back to Ole Miss again as a vice chancellor before becoming chancellor in 1995. On multiple occasions during the first five decades of Dr. Khayat's involvement with Ole Miss, the university attracted national media attention for racial issues—cross burnings, rioting, flag waving, "Dixie" playing, you name it.

But as I talked with Dr. Khayat that day as his retirement from a job well done loomed just months away, I realized that his sixth and final decade involved nothing of the sort. When Ole Miss has made national headlines in the new millennium, it has typically involved something bold, like hosting a presidential debate. The university is well on its way to redefining itself from being a poster child for the conflicted South to emerging as a recognized public university determined to lead on the national level.

Indeed, Ole Miss has changed. The institution is smarter. It is focused on the road ahead instead of on keeping things as they were. It wears its years of difficult experience well.

Now, the love only grows.

ACKNOWLEDGMENTS

First and foremost, a special thank-you goes to Bob Purser for his full cooperation in this story from inception to completion. He has been a champion of his father's and mother's work for years and was very helpful throughout manuscript development.

Thanks also goes to the Seaside Institute's Escape to Create program for giving me a home, nourishment, and inspiration for one month in early 2009 to write this manuscript. Authors dream of an idyllic setting and unencumbered time for writing, but rarely do matters work out that way. But the Escape to Create program, in its fifteenth year, has a unique way of fostering art by

providing wonderful homes, sandy beaches, outstanding food, and encouraging support to participants. I have long wanted to be part of the program but waited to apply until I had just the right book. I knew *The Education of Mr. Mayfield* was meant for Escape to Create, and the fit could not have been better. The program was a godsend. With a deadline looming and the book nothing more than a disassembled array of researched facts, I found that the month I spent as an artist-in-residence was just what I needed to bring this story to life. I thank Director Malayne Demars for overseeing the program and the entire Escape to Create committee for providing the opportunity.

I also acknowledge my fellow artists-in-residence, some of whom read parts of the manuscript as it was developed. They included Melanie Hammet, singer and songwriter; Rich Orloff, playwright; Ilari Kaila, composer; Dorothy Hammet, composer; and Wendy Reed, writer. Their friendship and laughter made a long month memorable.

Thanks go as well to my friends at Seaside's Modica Market and Sundog Books, two of the community's longest-established and most important businesses. My stay would not have been the same without the daily trips for lunch and inspiration to these locally owned establishments.

I am most grateful to my late father, Lyman Magee, who was so excited when I broached the subject of this book that his enthusiasm rivaled mine. I had a great angle, I told him—the story of an artist who was taught secretly

in a broom closet at Ole Miss by a risk-taking professor. I had no idea that my father had known Stuart Purser years before he was hired to start the Art Department at Ole Miss and more than a decade and a half before my father joined the university's faculty for a career of almost three decades. As a college student in Louisiana in the 1940s, he knew and admired Stuart and Mary Purser. One afternoon, he even took a photo of the couple. My father was elsewhere in graduate school when Purser spent his two years as a faculty member at Ole Miss. When told that I was writing a book based in part on the art professor and his wife, he retrieved the photo he had taken more than sixty years earlier. I was thrilled to get the picture and other background information included in this book. Nor had I known that Stuart Purser served as a mentor to my aunt while she was an art major at Louisiana College in the 1940s. My father ably filled in those details, too. When he worried that he would pass before the book got written, I laughed. Regrettably, he was right. Thank you, Dad, for being a small but valuable part of this remarkable story.

Another person who figured prominently in the development of this manuscript was journalist Jacob Threadgill, an Ole Miss student who provided valuable secondary research. He is a promising talent getting his start as a sportswriter, as I once did. I much appreciate his assistance.

I also thank the Pontotoc Historical Society of

Pontotoc, Mississippi, for the use of images from *The Baby Who Crawled Backwards: An Autobiography by M. B. Mayfield*. Here is what Mayfield himself had to say about those images: "I would like to explain that many of the photos of my artwork dates back to the late 1940's, also they were made with a wide variety of cameras, by a wide range of individuals who were not professionals. As for my opinion, 'A picture is worth a thousand words' even though it might not be top quality. I'm almost certain that shots of my work were done some time during every decade, from the 40's to the present time. I must confess that I owe my readers an apology if the quality of some of the snapshots is inferior. In spite of the obvious shortcomings I am fond of the collection. (They are family.)"

At John F. Blair, thanks go to President Carolyn Sakowski, who grabbed hold of my pitch for this book from the moment she received it, believing the story of Stuart Purser, M. B. Mayfield, and Ole Miss needed to be told. Such publishers are valued by writers like me who are passionate about important untold stories that may not make headlines but do create valuable opportunities for people who love to learn. Others at Blair deserving special mention include editor Steve Kirk and director of production Debra Long Hampton. I extend thanks to the entire team at John F. Blair for bringing this story to life.

Also, I would be remiss not to mention my wife, Kent, who graciously gave me the time and support to write the book, as did my children, William, Hudson,

and Mary Halley. And my mother, Betty, shared my father's enthusiasm for the story and pointed me in the right direction multiple times for interviews and insights related to the story of Purser, Mayfield, and Ole Miss.

Finally, readers desiring more information about M. B. Mayfield or Stuart Purser should visit or contact the following.

For copies of M. B. Mayfield's prints or his self-published book, contact the Pontotoc County Historical Society, P.O. Box 841, Pontotoc, Mississippi 38863.

For more information on Stuart or Mary Purser, including their works, visit www.purserstudio.com.

SOURCES

Researching a story that occurred almost six decades ago can prove challenging. Fortunately, both Stuart Purser and M. B. Mayfield left excellent legacies of their life experiences in self-published books. Purser's *Applehead* was helpful in understanding his growing up in Louisiana, while *An Autobiography of M. B. Mayfield* provided insight into key points in the artist's life from childhood through his return to Ole Miss in 1986.

I benefited from knowing since my youth the place where most of the story took place. I met Theora Hamblett inside her Oxford home and was a student of Faulkner not as a scholar but because the grounds of his Rowan Oak home were a childhood playground. I typically spent my Saturday afternoons as a child on the Oxford town square. Years later, I was a reporter and editor at the *Daily Mississippian*, the student newspaper at Ole Miss. I learned about Albin Krebs in the 1980s when he returned to make

his peace with the university. Much of my work on this book, then, was research through firsthand experience and osmosis.

Beyond the autobiographies of Purser and Mayfield, other sources also proved crucial.

My interviewees included Bob Purser; Ecru mayor Tom Todd; William R. Ferris, former director of the Center for the Study of Southern Culture at Ole Miss and currently professor of history and associate director of the Center for the Study of the American South at UNC–Chapel Hill; Anne Krebs Mansfield, Albin Krebs's sister; and Jo Ann Alsup, wife of former Ole Miss art professor George Alsup.

David Sansing's book *The University of Mississippi: A Sesquicentennial History* (University Press of Mississippi, 1999) was a vital source for key dates and occurrences in Ole Miss history, including information on James Meredith's enrollment, Blind Jim, William Faulkner, and the flag controversy of the 1980s. *Conversations with William Faulkner* (University Press of Mississippi, 1999) provided details of the conversations between Purser and Faulkner about Mayfield related in chapter 4 of this book.

I used news reports from the *Oxford Eagle* and the *Daily Mississippian* regarding the premiere of *Intruder in the Dust*. The *Eagle* also provided information about Purser's winning first place in the New Orleans art contest, the 1950 "Welcome, Rebel" party, the beer sales controversy,

and Faulkner's Nobel Prize award and ceremony. The *Daily Mississippian* was my source for information regarding Krebs's editorial controversy. The quotes from President Kennedy regarding the Meredith rioting are from *The Fiery Cross* by Wyn Craig Wade (Oxford University Press, 1998). All information and quotes about sculptor Jesse Aaron are from Purser's self-published book *Jesse J. Aaron: Sculptor*. The piece in chapter 9 by Galen Holley, religion editor of the *Northeast Mississippi Daily Journal*, appeared on January 17, 2009, and is used courtesy of the newspaper. The quote from David Sansing in chapter 10 regarding the presidential debate at Ole Miss appeared in an Associated Press article on September 21, 2008.

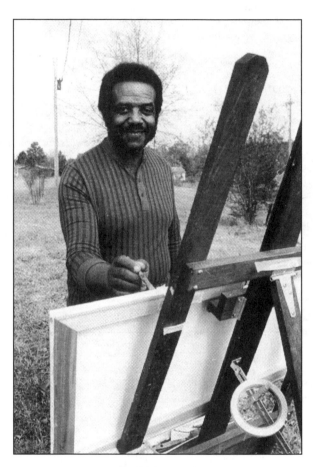

Mayfield at work